LEONARDO

LEONARDO
Patricia Emison

To all those whose curiosity has not been tamed by practicality.

Phaidon Press Limited
Regent's Wharf, All Saints Street, London N1 9PA

Phaidon Press Inc.
18 Varick Street, New York, NY 10014

www.phaidon.com

First published 2011
© 2011 Phaidon Press Limited

ISBN 978 0 7148 6255 2

A CIP catalogue record of this book is available from the
British Library

Printed in Singapore

Picture Credits
Plates 15, 16, 28 & Figs 12, 22, 30, 33, 42: © 2011. Photo Scala, Florence;
Plates 1, 9, 10, 22 & Figs 4, 19: © 2011. Photo Scala, Florence – Courtesy of
the Ministero Beni e Att. Culturali ; Fig. 27: © 2011. Image copyright The
Metropolitan Museum of Art/Art Resource/Scala, Florence; Plate 34: ©
2011. White Images/Scala, Florence.

Note: All dimensions of works are given height before width.

Cover Illustrations:
Front, *Portrait of Lisa Gherardini, Wife of Francesco del Giocondo*,
1503–6 (Plate 33)
Back, *Warrior with Helmet and Breastplate in Profile*, c.1475–80
(Plate 6)

Leonardo

Some great artists define a period, as Picasso did; others, like Manet, defy periodization. Leonardo da Vinci (1452–1519), paradoxically, accomplished both. His career opens that episode of extraordinary artistic flourishing called the High Renaissance. Yet both his art and his life were in many ways atypical of his time.

The artist and art historian Giorgio Vasari (1511–74) credited Leonardo with starting the period of what he called 'modern art'. He saw Michelangelo as finishing the period, having pushed sixteenth-century art to the point that it surpassed that of the ancient Romans. Leonardo tried to paint what was intangible yet worldly; Michelangelo focused on the writhing male nude, preferably carved in marble and often as a kind of symbol of the suffering soul. Between those two poles High Renaissance art covered much ground.

When the nineteenth-century historian Jules Michelet started to write about the Renaissance as a pivotal period in the history of France, he featured Leonardo, who died in France, painter to the king and according to legend at least, much esteemed by him (Fig. 1). Between the attention given to him by Vasari and that by Michelet, by the first art historian and the first historian of the Renaissance, Leonardo was assured a central role in the history of art, and with good reason. Not merely an eccentric genius, Leonardo changed the world, even if on the surface his life might seem one of unfulfilled promise. He not only inaugurated the High Renaissance, which competed for centuries with ancient art as the model for good artistic style, but inadvertently and gradually developed into the premier example of the 'Renaissance man', a person who didn't have to specialize to achieve excellence. His work as draughtsman, painter, sculptor, architect, anatomist and engineer continues to be worthy of interest; he collaborated with the best mathematicians of his day (including Luca Pacioli, who had known both Piero della Francesca and Leon Battista Alberti); and he played the lute and sang beautifully.

Two technical innovations were crucial to Leonardo's stylistic achievements. The introduction of the oil medium for pigment, in place of egg tempera, had begun in Italy before Leonardo's time, but he was the first to exploit fully the potential of the new medium. The transparency of shadows and the effects of reflected light, in which he revelled, could not have been matched in tempera. Oil also allowed for slower work; each stroke could be revised, which had not been the case before and which suited Leonardo's temperament. The other technical milestone was the development of a fixative for chalk drawings. Although early in his career he made meticulous metalpoint drawings with precisely placed parallel hatching lines, he soon came to prefer the approximate mark of friable, smudgeable chalk. As a parallel resource, he began to draw sketchily in pen, as no one else yet had. If he had accomplished no more than to make the first pen sketches in which capturing movement outweighed notions of ideal form (Fig. 2), for that alone he would have earned an important place in the history of art.

Vasari praised Leonardo for showing the way to a new level of naturalism, one that showed 'grace' rather than seeming too studied, hard and, as Vasari also liked to put it, dry. Oil paint flows thickly on to its support, whereas tempera paint is applied thinly and does in fact dry very quickly. Vasari was also impressed by the rank of Leonardo's patrons: not merely the republic of Florence (extinct in Vasari's day) but duke, king, cardinal and pope. In the more courtly world of sixteenth-century Europe, women's taste was more crucial than it had been in the brusque world of mercantile Florence, and Leonardo's style was both

Fig. 1
J.-A.-D. Ingres (1780–1867)
Death of Leonardo da Vinci
1811. Oil on canvas, 40 × 50.5 cm.
Musée du Petit Palais, Paris

Fig. 2 *(opposite)*
Studies of a Child with a Cat
1478–81. Pen and ink, 20.6 × 14.3 cm.
British Museum, London

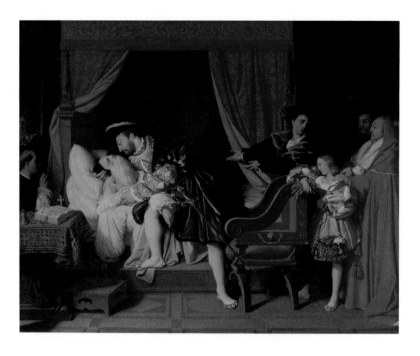

flattering in its portrayal of women (*grazia*, although not exclusively a feminine quality, was particularly prized in women) and appealing to their taste. Andrea Mantegna, for instance, had been criticized for his unflattering portrayal of women, and for this his essential linearity was to blame. The notoriously vain Isabella d'Este, who showed no interest in being painted by Mantegna, the resident artist at her court in Mantua, put a good deal of effort into pursuing portraits by Leonardo, although only a rather unsatisfactory preparatory design has come down to us of her own portrait, likely to have been made while she was quite heavily pregnant with the future Duke of Mantua (Fig. 3). Leonardo was skilled in portraying figures of both sexes and varied ages, although his characteristic *sfumato* (a smokey, evanescent rendering of contour) was particularly suited to depicting the soft flesh of young women in a way that appealed to touch as well as sight. Michelangelo famously decried the feminine taste for landscape and pious pictures, at both of which Leonardo excelled. His achievements inspired Raphael, who specialized in portraying beautiful women. Vasari criticized Raphael for learning so much from Leonardo, but then, the hero of his history was Michelangelo. From our less partisan standpoint, we might instead admire Raphael's facility at assimilating the lessons of Leonardo; he worked in proximity to the elder artist both in Florence and later in Rome, although we know very little about how they got on with each other.

Leonardo left Florence for Milan when he was barely thirty. By that time he had made, as far as we know, only a handful of independent paintings, including the Madonna and Child at least twice, an Annunciation, a portrait – and most intriguingly, while still only a youth, a head of Medusa on the back of a wooden shield, long since lost. This his father recognized as something special, though also horrifying. Giving a substitute to the peasant for whom it had been made, he sold it, and then, Vasari reports, it was resold at great profit to the Duke of Milan, presumably the cruel Galeazzo Maria Sforza (d. 1476), brother of Ludovico Sforza, regent and then duke, for whom Leonardo later worked. When Leonardo made a list of his works, possibly around this time, he ordered them in terms of ideas, not by their value or medium. Works in pen are listed alongside what may be paintings, and studies next to finished or 'almost finished' works. Perspective studies, anatomical

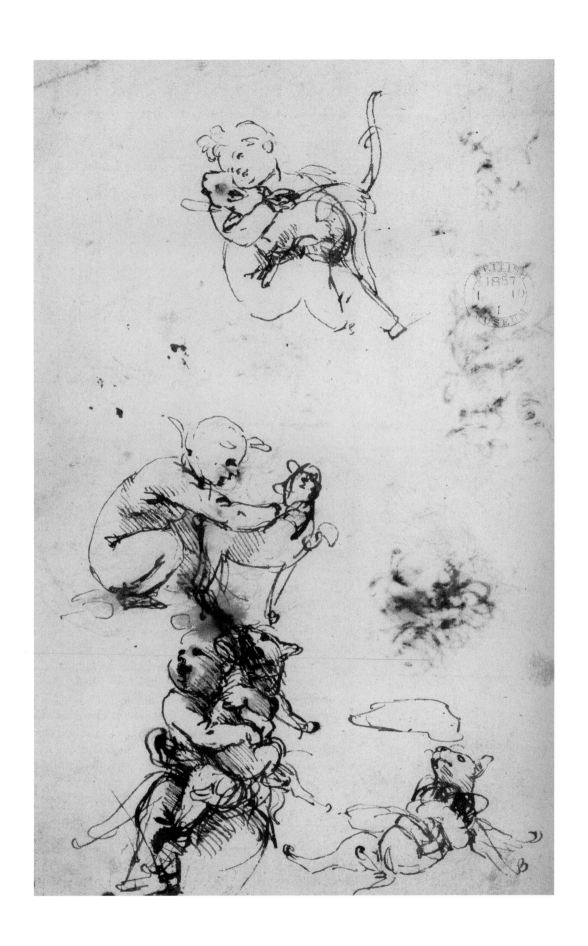

Fig.3
Half-length Portrait of a Young
Woman in Profile (Isabella d'Este)
*c.*1499/1500. Black and red chalk on paper,
pricked, 63 × 46 cm.
Musée du Louvre, Paris

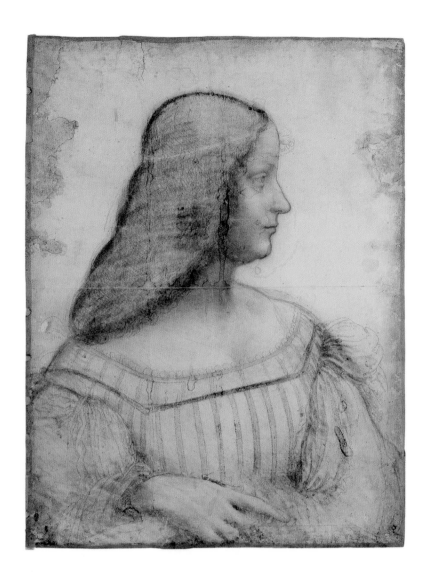

studies, knots and designs for machines are included. Rather like the Roman author Pliny, who studied the visual arts as part of natural history, Leonardo also included on his list a chalcedony, a mineral specimen.

His largest commission during his first Florentine period, an *Adoration of the Magi* (Plate 9), he left unfinished – an early instance of what would develop into something of a habit. The artist who took over the commission began with a new panel of the same size, which is clear evidence that Leonardo was considered an extraordinary artist even at this relatively early date. Presumably it was hoped that he would eventually finish the panel. The Madonna and Child sit at the centre, anchoring what is otherwise a near chaotic plethora of figures in motion. Fingers, hair, facial muscles, all are caught in the midst of movement, yet Leonardo binds the whole together deftly with washes, which would later have been worked up into permeating shadows. These shadows do not merely amplify the three-dimensionality of particular forms in the standard way, but help to establish the coherence of the whole space.

Leonardo thought about the world very differently from his peers; both his notebooks and his art give ample evidence of this singularity. It has long been suspected that a more or less repressed homosexuality may have contributed to his sense of himself as outside of local norms. Leonardo was charged with sodomy in 1476, although the accusation was dropped later. We would not expect Vasari to include any hint of abnormality in his biography and he didn't. Gian Paolo Lomazzo in

his unpublished *Libro dei Sogni* of 1563 includes a dialogue in which Leonardo acknowledges that he has, 'in the Florentine way' (as it is somewhat facetiously described), had relations with his apprentice Salai (a shortened form of '*Salaino*', or 'little devil'), who was ten when he entered the studio. He stayed with Leonardo almost thirty years. Leonardo left him half a vineyard near Milan; Salai returned to Italy, married, and was killed in 1524, probably by French troops. The matter is brought up again by Sigmund Freud, who wrote a short book about the artist in 1910. In a long and sometimes clearly mistaken discussion that has elicited much correction since, Freud eloquently explored how even so exceptional a person as Leonardo might be understood according to common psychological patterns. He begins apologetically, explaining that he has nothing to offer on the question of Leonardo's creativity. Instead, he addressed himself to Leonardo's failure to finish projects, as well as his recurrent use of nearly the same figure wearing a very similar smile, which Freud interpreted as reflecting a childhood memory of his mother (presumably he was nursed as a baby by his mother, before being taken into his paternal household).

There isn't much solid evidence about Leonardo's sexual orientation other than a lack of personal interest in women and the early arrest, both of which are sufficient to establish a near certainty that he was not routinely heterosexual. And while this is not the place to investigate the complexities of sexuality and gender as factors in the making of a personal style, it can be said that Leonardo developed the ability to render the softness of female flesh and the floating quality of diaphanous drapery in paint far more convincingly than any of his contemporaries. We may even infer that he was especially adept at developing a rapport with his female sitters and put them at their ease. On the other hand, his aptness as sculptor of a ferocious and commanding equestrian general was equally recognized (see Plate 17). That the chance to work on such a commission was a factor in his removal to Milan is clear from the draft of his letter to the duke applying for a position at the court. The republic of Florence was not fertile territory for an equestrian monument, which functioned as an image of absolute power. Donatello had moved for several years to Padua to make an equestrian monument, and Leonardo's own teacher, Andrea del Verrocchio, would soon go to Venice for the same reason. Leonardo's letter makes for sobering reading, in that he recommended himself to his prospective employer as a military engineer primarily, secondarily as a sculptor, and lastly as a painter. He arrived with a silver lute in the form of a horse's head – a strange and unusual thing, as Vasari assures us, with which he entertained the court.

Much of Leonardo's Florentine work was creditable rather than extraordinary. The *Munich Madonna* (Fig. 18) is fussy and overdecorated, an example of a young artist attempting to resolve too many issues at once. Although in retrospect it has all the promise of what was to come, it lacks the concentrated effect of his more mature work. The *Benois Madonna* (Plate 8) already benefits from the process of distillation: the girlish Madonna almost seems younger than the studious infant, and the props, no longer distracting, enhance this characterization. The grave *Ginevra de' Benci* (Plate 7) distinctly still belongs to the fifteenth century; it is the painted analogue to Verrocchio's impassive yet hugely impressive marble bust of the *Lady with Flowers* (Fig. 4): breathtaking in its purity and clarity of form, from the transparent gauze of her garment to the shimmering surface of the reflective water. Already Leonardo could paint glistening hair as no one else could; already he could put into practice the idea of the eyes as the windows of the soul, and transcribe his sitter's steady gaze without flinching. Yet in this case the soul is still somewhat reticent and the water lies still; each hair has been

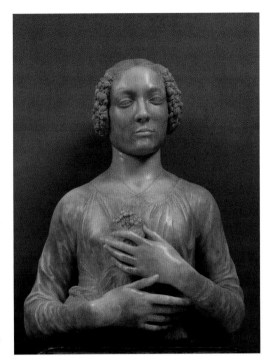

Fig.4
Andrea del Verrocchio
(*c*.1435–88)
Portrait Bust of a Lady with Flowers
1475–80. Marble, 61 cm height.
Museo Nazionale del Bargello, Florence

Fig.5
Study of the Hanged Bernardo di
Bandino Baronceli, December 1479
1479. Pen and ink, 19.2 × 7.8 cm.
Musée Bonnat, Bayonne

Fig.6 *(opposite)*
A Young Woman Pointing,
*c.*1513. Black chalk, 21 × 13.5 cm.
Royal Collection, Windsor

described individually and the effect is frozen rather than fully lifelike. He corrected the faults of this portrait thirty years later, while resident again in Florence, as he painted the *Mona Lisa* (Plate 33). The difference between those two portraits, one exquisite and the other evocative, is the difference between an art that idealizes objective reality and an art that idealizes a person's interior life. Very few artists were able to match this particular challenge set by Leonardo, though many learned to avoid sharp outlines and to imitate the narrow facial type preferred by Leonardo (and which *Ginevra* lacked). The rather sallow colouring characteristic of his mature work reflects both his prioritizing of tonal unity over the allure of hue and, to some degree, the ageing of varnish.

Verrocchio was no genius as an artist, yet Leonardo's work in many ways grew directly out of his master's. The *Ginevra* reflects his familiarity with Verrocchio's beautiful and unusual bust, and his designs for an equestrian monument show him attempting to outdo his master by having both front hooves raised in a rearing motion (see Plate 17), rather than – Verrocchio's proud achievement – to have a single prancing hoof lifted into the air. It is fascinating to watch the good work transformed into something much more special, if only on paper in this instance. Although Vasari judged the success of the work of the sixteenth century in terms of its competition with great works surviving from antiquity, little painting remained from antiquity for painters to study. They were left to compete against sculpture old and new, to vie with nature, or to defy their masters and out-paint them. Leonardo famously declared that it was a poor pupil who didn't exceed his master, a sentiment that sounds much more acceptable now than it would have in his day.

In his more theoretically inclined moments, Leonardo argued that painting was as noble as the more respected arts of poetry or music. He was himself not only a lutenist but a brilliant improvisor. The idea of a parallel between music and painting scarcely existed before he wrote about it. On a practical level, Vasari tells us that Leonardo brought in musicians to play for Mona Lisa, to avoid the characteristic pout on the faces of bored portrait sitters (such as Ginevra, one might suppose). The parallel with music amounted to more than mere talk; it may have prompted Leonardo to think about painting in new ways. The importance of tonal harmony and the relative unimportance of narration, taken for granted in music, were barely thought about by most painters of the time. Much later Whistler and Kandinsky helped to oust the literary bias of visual art by appealing to the non-representational example of music, and thought they were doing something quite new. Music in Leonardo's day was flourishing and innovative, if still not wildly varied in expressive quality. The court at Milan was well supplied with expert musicians, and it may have been with them that Leonardo found the companionship that in Florence would have been more readily at hand with visual artists. The most famous musicians came from northern Europe, as did the use of the oil medium and the prominence of landscape painting. Of all the Florentine Renaissance artists, Leonardo was the least oriented towards Rome and the most receptive to the lessons to be learned from Netherlandish art. Their realism was compatible with his empirical tendency, but what in Netherlandish art entailed a willingness to include wrinkles in the skin and to expend an enormous effort in transcribing correctly the fissures in a fur hem as it bent against the hard floor, in Leonardo led to so unlikely a result as a portrait of a young woman holding an ermine in her arms, the fur studied meticulously but the image as a whole extremely unrealistic and indeed laced with wit, perhaps even with irony.

Although he was obsessed with the new challenge of conveying the interior life of his figures, Leonardo was at the same time an innovative

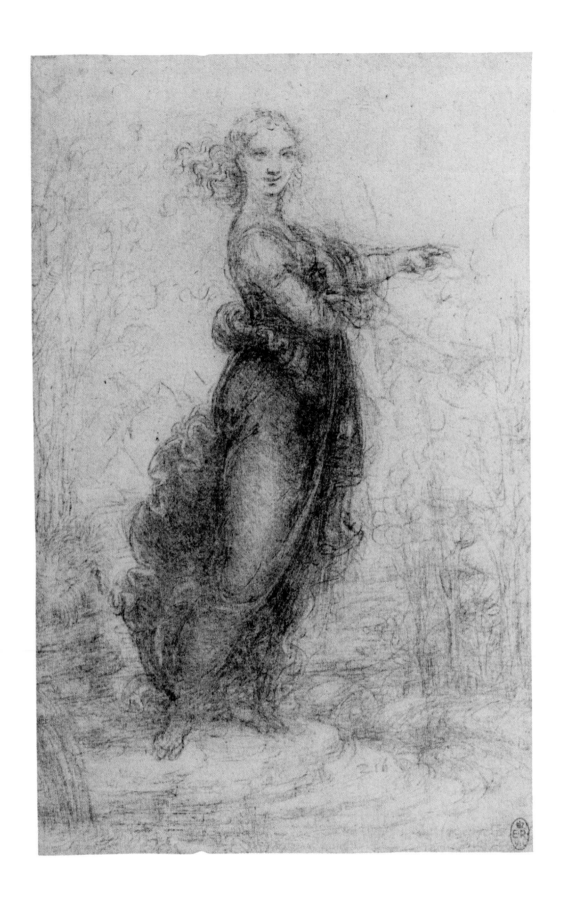

Fig.7
Allegories of Pleasure and Pain
and of Envy
*c.*1483–5. Pen and ink, 21 × 29 cm.
Christ Church, Oxford

and eager empiricist. No other artist had sought so determinedly to paint what struck him in the everyday, from flowers and foliage, to drapery carefully arrayed, to squirming cats. On 5 August 1473, when he was twenty-one, Leonardo went out for a walk in the hills and made a detailed pen drawing of the full range of rock, field and sky he could see from his chosen vantage point (Plate 1). The inscription he made implies that he recognized that what he was doing was thoroughly new, in an age that still didn't know that it prized experiment as well as tradition. Leonardo advised young artists to carry pen and paper with them and to draw from life, and his impromptu sketch (Fig. 5) of the body of a conspirator against the Medici, hanging from the window of the Palazzo della Signoria is evidence of this practice. After generations of stock poses for the baby Jesus, Leonardo took up pen and paper to try to capture the movements of wriggling, grasping babies. It was left for his successors, Raphael first of all and later Correggio, to translate this into more convincingly intimate and tender scenes of Madonna and Child, but the resolution to sketch from unposed and even impetuous life was Leonardo's innovation. It entailed a willingness to abandon the neat hatching associated with metalpoint drawing in favour of messy, more gestural work. It led him to try to draw such intractable subjects as rapidly flowing water, which he compared both in words and images to flowing hair, each of them presenting similarly complicated surfaces glimpsed by their reflected light. The lighting characteristic of Leonardo's paintings is the evening lighting he recommended in his notebooks, the gentle half-light of dusk that softens the planes of the face, lending it that ineffable *grazia*, and rendering it, in Leonardo's opinion, as beautiful as possible. Most Florentine fifteenth-century painting had favoured the bright light of midday, with minimal shadow, with everything laid out clearly for the viewer. Leonardo made paintings that encouraged more active viewing. One needed to crane close to see the subtle effects of glinting light and implied movement, whether in the face, neck or hands, or even mist or long-stemmed, heavily weighted flowers and grasses. Caravaggio and Rembrandt would go on to compose canvases with large pools of impenetrable darkness; Leonardo's tactic was instead to achieve a half-light in which forms could be discerned, but in which the panel gave its image to the viewer quietly, as though muted, should the viewer be willing to attend carefully. He always liked to portray the barely visible, whether it was the gauze of Ginevra de' Benci's chemise, or the mist and

haze in the background of the *Virgin of the Rocks* (Plate 41), or the earth as it was pounded by deluge (Plates 46 and 47). This is one of his great contributions to art, the preference for the visualization of the barely visible, for providing just enough to engage the viewer's imagination. It's well known that Leonardo balked at completing two heads in the *Last Supper* (Plate 26): the supremely beautiful head of Christ and the unfathomably villainous head of Judas. His difficulties there may have led him eventually to the realization that sometimes an artist accomplishes more by implication than by declaration. His recurrent pointing figures – for instance, the youth near the tree in the *Adoration*, a disciple in the *Last Supper*, Saint Anne in the London cartoon (Plate 31), the smiling John the Baptist (Plate 48) from late in his life, the pointing and also smiling girl in a chalk drawing (Fig. 6) – invite the viewer to complete the picture's meaning, perhaps even to complete it by wondering at the heavenly mysteries. The idea of a visual puzzle might have its germ in the use of emblems, a type of image for which Leonardo had a taste. He himself penned short fables, vaguely modelled on Aesop, a favourite author during the period and one who appears in his lists of books. He would have known Alberti's enigmatic emblem, the winged eye with the motto, '*Quid tum?*' ('What then?'). He liked to sketch little allegorical interludes (Fig. 7).

Despite that side of his taste, Leonardo was emphatically the first empiricist in the history of art, and, as such, a legitimate forerunner of the scientists who followed not that far behind: Andreas Vesalius, Nicolaus Copernicus, Tycho Brahe. 'All our knowledge begins in the senses', he advised, and 'experience never errs, only your judgements'. Leonardo relied on and yet always questioned his senses. It requires some effort on our part to reconstruct how abstracted from the experience of sight Italian art was before, and in some cases also after, Leonardo redirected it. Michelangelo's art, for instance, stubbornly ignored Leonardo's lessons. The debates that erupted during the Counter-Reformation between an art of *ritrarre* (truthfulness to nature, as in a portrait) and *imitare* (an idealization justified as compensating for the deficiencies of the material world) can be traced back to their opposed styles.

Leonardo looked at a copse and could see the whole as well as the parts (Plate 30). He drew what he saw: patterns of light and shade that transcend the individual leaves. He was able to think about those myriad leaves collectively, studying a complexity of light and shade that was beyond meticulous analysis and required some intuitive grasp. He wanted to understand not just art, but life, and also death, and so he spent long hours trying to dissect corpses, a study he undertook over many years, in both Florence (at Santa Maria Nuova, still functioning as a hospital) and Milan. The painter, sculptor and engraver Antonio del Pollaiuolo had done this before him; but Leonardo did more extensive dissection (more than thirty bodies, he reported), and not simply in order to understand how to draw the skeletal and muscular systems more effectively, but because he wanted to take the human body apart and see what made it work – or alternatively, why it stopped working the way it did. As he wrote in a note to himself, he dissected a 100-year-old man, hoping to discover what had induced so easy a death ('*si dolce morte*'), and attributing it, plausibly enough, to a lack of blood in the arteries. Leonardo certainly didn't anticipate William Harvey on the circulation of blood, but as in many areas of science, he had excellent intuitions. He wanted to understand the muscles of arms and wings, ageing and breath, birth and sexual intercourse (Fig. 8) – not in order to make a racy picture of the latter (as his contemporaries were on the verge of doing), but simply in order to understand the mechanics of

Fig.8
The Sexual Act in Vertical Section
c.1490. Pen and brown ink,
27.6 × 20.4 cm.
Royal Collection, Windsor

life (such as the spine being considered the source of semen, a view he inherited). One of the stories that comes down to us about Leonardo is that he would go to the bird market, buy a bird and set it free – whether simply to observe flight from as close as possible, or because the caged birds elicited his sympathy. He kept a strange lizard when he lived in Rome and made props for it so that he could frighten people by showing it. He dissected animals (including pithing a frog) as well as human bodies. On occasion he would inflate the innards of animals to fill up rooms and cause people to stand aside, saying as he did so that talent was like this, and could become unexpectedly important. He especially admired horses, being both powerful and graceful at once.

Before Leonardo, nobody had articulated why a literate person should care about pictures – other than that the ancients had cared about them. Even Alberti, author of the first treatise on painting in modern times, champion of the visual arts, had considered the primacy of text a foregone conclusion. Alberti was proficient in both Latin and Greek. Texts were his business; painting was merely his recreation. For Alberti, pictures were important because they related to texts, and history painting was more important than portraiture for the same reason. The much younger Leonardo – who bemoaned his lack of education in a phrase that has echoed very oddly down the centuries, his depreciation of himself as '*omo sanza lettere*' (a person untrained in Latin) – provided the model of the highly intelligent person whose training was technical and manual rather than bookish. He made various lists of his books, including works by Dante and Petrarch, and in a lighter vein, a book of jokes by Poggio Bracciolini (in Latin), as well as Luigi Pulci's humorous Italian poem, 'Morgante'. He was somewhat defensive about his lack of proper training in Latin, which was the language of learned discourse in his day, and obtained a copy of Donatus, a Latin grammar. He owned Pliny's *Natural History*, the Bible, Latin texts on anatomy and physics, cosmology, and, not least, a copy of Vitruvius's treatise on architecture (not available in Italian until after Leonardo's death). He made notes in reference to Alberti's Latin treatise on architecture in his notebooks. He may have worked all the harder to compensate for his lack of formal education; and because he could not pursue scholarship at the level of the humanists, he put much of his energy into studying what he could see. He combined an unfettered curiosity with imagination and expressed his vision with a level of skill and expertise that writers could recognize as comparable to any they might claim for themselves in the medium of words. The Roman poet Horace had famously compared poetry and painting, and humanists were eager to follow his example, even if they assumed, as he had, that writers necessarily took precedence. When Leonardo wrote in his notebooks about the nobility of painting, he praised it as better than poetry, better than sculpture and better than music, because it affected the viewer more powerfully than any of the other arts.

He told the story of a man who had fallen in love with a painting, a portrait of a woman, and who finally removed the painting in order to eliminate its power over him. The ultimate power of painting, Leonardo recognized as humanists often failed to, was emotional. Even in the context of a culture that preached against idolizing images, it was possible to love a painting. Leonardo not only cherished everything he could see of the natural world – everything from skulls to dissected soft tissue, from sedimentary rocks to marshy vegetation – but he also loved the evidence of process in the natural world: variability in weather and lighting conditions, the movement of water and wind, the change across the face as thoughts and emotions came and went. He grew up in a Florence that was deeply interested in Socrates' teachings about eternal

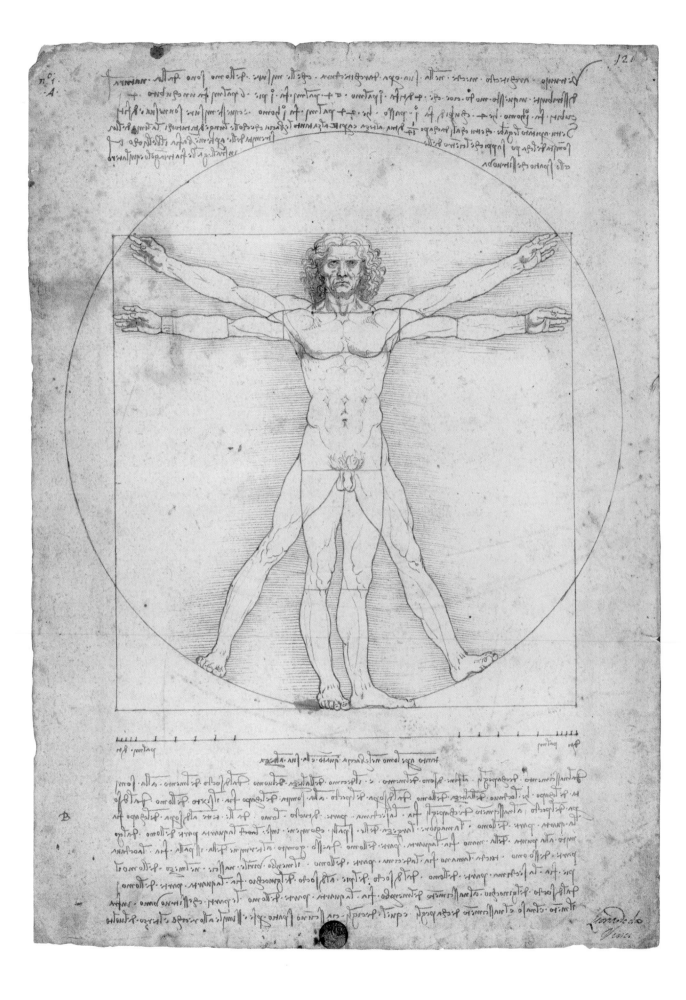

forms, and afterwards lived in a Milan that was still busy constructing a medieval cathedral and whose duke lived in a medieval castle nearly devoid of good paintings. He might very well have perfected painting along the dominant lines followed in either city, or some combination of the two. Instead, he reinvented what painting should be about. Exactly unlike an icon, a painting should seem ephemeral, in the same way that experience was. Of this latter truth, Leonardo was acutely aware. He was tormented by the inexorable passage of time, 'that swift predator and destroyer of everything made', as he called it.

In his new definition of the medium, painting should seem as insubstantial as light and air, fluid and soft, rather than stable and solid. The world should be shown to be in flux. Between painting *Ginevra* and the *Mona Lisa*, Leonardo learned exactly that: his objective was newly defined as an image that seemed as fragile and temporary, and as marvellous, as what was seen in life. Earlier artists had striven to make what they painted seem permanent and solid. Leonardo confronted the contradiction between this goal and the objective of lifelikeness. For Leonardo, lifelikeness could be captured only if the flitting quality of shadow and the murkiness of half-light could be represented. He did not want his paintings to look like sculptures, but like palpitating, fragile life. As a dissector of corpses, he knew very well the difference between a three-dimensional body and a living being. That difference he strove to capture. Although Vasari never saw the *Mona Lisa*, his description of it does justice to Leonardo's style: he claimed that it could not be more natural or lifelike, that the painting demonstrated the degree to which art can imitate nature. Walter Pater's long-famous and gorgeous description of the painting in 1869, by contrast, reeks of Romanticism and has rather little to do with the painting itself, despite his having had access to it. He begins, 'The presence that rose thus so strangely beside the waters, is expressive of what in the ways of a thousand years men had come to desire.'

'The movement of body should express movement of soul' was Leonardo's basic advice about painting. That advice heralded a shift away from programmatic content towards a more ineffable visual poetry. Vagueness he sought first in contours, because as he claimed, one did not see harsh straight lines in nature. Only later did he extrapolate from this to a preference for some vagueness in the content of his pictures. His most loyal Venetian imitator, Giorgione, developed the pastoral genre, within which mood and colour harmonies prevailed rather than narrative action and a range of clearly expressed emotions. Leonardo never took that direction, but such a painting as the late *John the Baptist* was a study in evocation rather than declaration. The great watershed between narrative clarity and the suggestion of mood and atmosphere can be isolated in his largest and most elaborate surviving painting, the *Last Supper* for the Dominican friars' refectory adjacent to Santa Maria delle Grazie, a church that was being built by Donato Bramante for Duke Ludovico Sforza. Here he orchestrated figures for the sake of clear dramatic effect. Christ has just announced, 'One of you shall betray me', to which all disciples react with consternation, each in his own key. Young and old, gesticulating with open gestures or closed ones, they are symmetrically arranged in groups of three on either side of Christ, who is framed by the window pediment far behind him and the lighter landscape even further beyond. One group of three includes the villain Judas. It was a *tour de force* to place Judas on the far side of the table with the others – Leonardo's way of boasting that his powers of characterization were so replete that there could be no ambiguity about which of the twelve was damned. No ambiguity indeed, yet there is subtlety. It might take the viewer a moment to pick out the

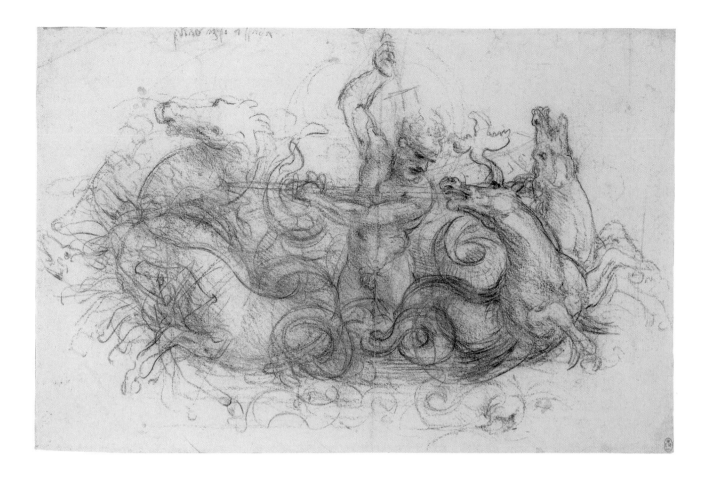

Fig.10
Neptune with Four Seahorses
(*Quos ego*)
*c.*1502–4. Black chalk, 25.1 × 39.2 cm.
Royal Collection, Windsor

villain, a moment to register the individuality of each distressed disciple. Judas holds a moneybag and draws away from Christ; he is shown in profile with bent beak and low forehead; he wears dull brown. This is the last time Leonardo would box himself in with a linear perspective construction, with a room oddly proportioned for its contents. The long table is crosswise in a long room, whose side walls are punctuated by alternating doorways and tapestries, all to ensure that the rhythm of recession is securely established. The vanishing point, which ideally would be placed opposite the viewer's line of sight, is of necessity above the viewer's head, so the perspective effect is less than optimal, as was so often the case. And although Leonardo's reputation was formed early and lasted long, the door cut through the wall in 1652 reminds us that this work has not always seemed as special as it does now. On the one hand, both Louis XII and Napoleon are said to have wanted to claim it as a spoil of war and had to be persuaded not to move the fresco; on the other hand, even by Vasari's day, Leonardo's attempts to enhance the colouring feasible with normal fresco technique had already resulted in a ruinous condition – although Vasari still highly praised the painting of the tablecloth. The first complaint about this work's condition dates to 1517.

Leonardo's equestrian project also ended unsatisfactorily. A clay model was put on display late in 1493. But like Michelangelo, whose project for the tomb of Julius II was impossibly ambitious, Leonardo took on too much. The project of a colossal bronze monument (perhaps over six metres tall) in a pose of unprecedented movement and difficult balance would have been extremely tricky, as well as expensive, to cast. In the end, the model was used for target practice by French archers during the occupation. Leonardo continued to sketch equestrian monuments and to hope to convince whoever was in power to build one, until he left Milan in 1513. He also drew his ideas for buildings over many

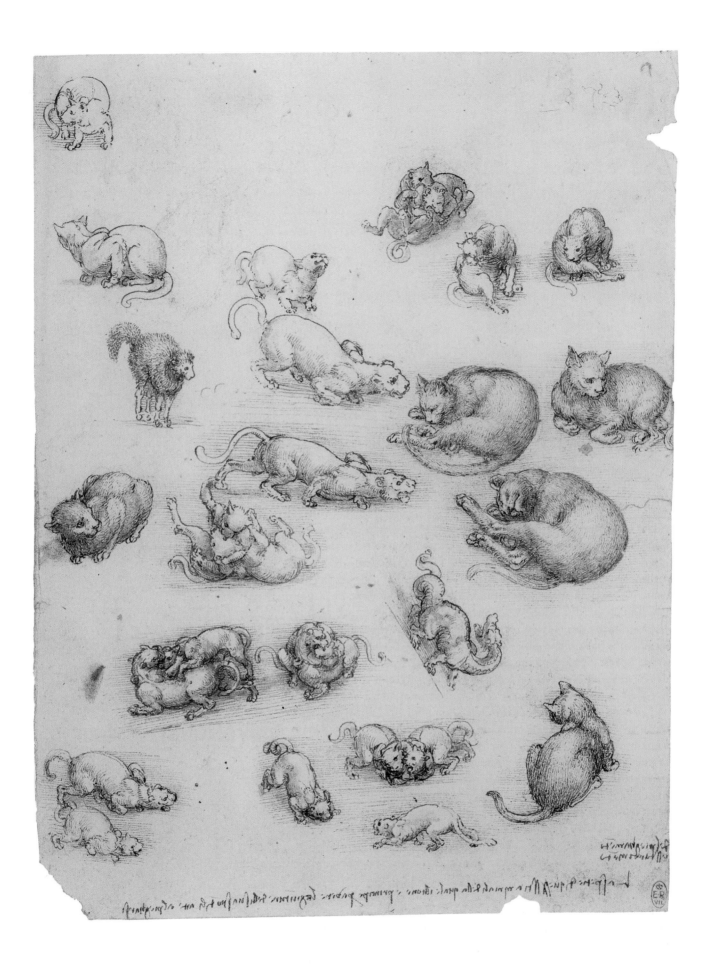

years, but never saw them come to fruition. He was consulted about the ongoing building of the cathedral in Milan and he was probably a source of ideas for the new St Peter's; Bramante and Raphael, both friends from Urbino who each in turn became chief architect of the project, shared Leonardo's strong preference for the centralized plan. He may have shared his architectural ideas with others in France; tradition credits him with certain architectural innovations at the château of Chambord, notably the spectacular double spiral staircase, although actual construction post-dates his death.

Leonardo owned a copy of Vitruvius's *De architectura*, the sole treatise about art to have survived from antiquity, and he illustrated Vitruvius's explanation of the perfection of the human form: its proportionality and symmetry as demonstrated by its conformity to circle and square (Fig. 9). By one of those quirks of history, he is now known best, perhaps, for a drawing that shows him in an uncharacteristically derivative light, and also uncharacteristically subservient to the example of the ancients. But because it showed Leonardo as a quintessential Renaissance thinker, glorifying the human form and antiquity both, the drawing has often been reproduced in textbooks. Leonardo was inspired by Vitruvius to do extensive studies of anatomical proportion, both human and horse, and often referred to Vitruvius in his notebooks. Leonardo's drawing had no currency in its time; an illustrated edition of Vitruvius was first published in 1511 by Fra Giovanni Giocondo and ten years later an Italian edition, by Cesare Cesariano, was published. They both inscribed the circle in the square and stretched the figure to fit, whereas the more empirically-bent Leonardo arranged the circle and square with different centres, so that the figure fitted more naturally.

The chalk drawing that seems to show the *Quos ego* (Fig. 10) – Neptune arising from the sea to quell the winds that had been accidentally unleashed by the disobedience of Ulysses' men as told by Homer – is uncharacteristic of Leonardo in its appeal to ancient poetry. Still, the subject suited him in its inclusion of horses, in Neptune's combination of power and age, and in the theme of destructive nature. The drawing we have seems to be a study for a finished drawing presented to a Florentine friend, Antonio Segni, the same man for whom Sandro Botticelli painted the *Calumny of Apelles* (Galleria degli Uffizi, Florence). For the most part, Leonardo seems to have taken his own advice to heart, and to have felt that he didn't need to rely on the poets for his subjects.

The Battle of Anghiari (see Fig. 34), commissioned for the council chamber of the Palazzo della Signoria by the newly established Florentine republican government trying to recoup from the rule first of the Medici and then the severity of the Dominican, Girolamo Savonarola, should have been the largest of all his projects, perhaps three times the size of the *Last Supper*. How colourful it would have been we cannot say, for Leonardo, although he started on the wall after extensive preparatory work, once again let his technical experiments lead him to disaster. This time, the pigments failed him so utterly that the project was abandoned before it was finished. What he had done remained on the wall to the admiration of artists and amateurs alike, seemingly until Vasari painted the wall in the 1560s.

Equestrian battles were a standard subject for Roman sarcophagi, but none showed wildly twisting rearing frantic horses to match Leonardo's. Somewhat oddly, he was assigned as subject a battle the Florentines won against the Milanese – as though the Florentines wanted to force him to declare where his allegiance lay. From his sketch sheets we can follow how Leonardo would watch a cat twisting and jumping, and then move on an inch or two to draw rearing horses and fighting dragons,

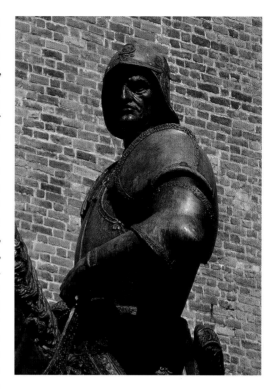

Fig.11 *(opposite)*
Studies of Cats, a Dragon and
Other Animals
*c.*1517–18. Pen and ink and wash
over black chalk, 29.8 × 21 cm.
Royal Collection, Windsor

Fig.12
Andrea del Verrocchio
Equestrian Monument of
Bartolommeo Colleoni (detail)
*c.*1483–8. Bronze, 4 m height.
Campo dei Santi Giovanni e Paolo, Venice

presumably all in a matter of minutes (Fig. 11). Other drawings show Leonardo exploring extremes of facial expression, more so even than in the *Last Supper*, and not only facial expression, but actions that involve every muscle from head to foot. The glaring face of the warrior is unforgettable (Plate 38). No typical hero is this, but an ordinary man in an extraordinary moment, straining to his utmost. Effort, rather than nobility, is what the image conveys. Before Leonardo, such roaring, grimacing figures were more customarily found in depictions of hell (although it is perhaps worth noting that the Florentine Antonio Pollaiuolo's engraving of the *Battle of the Nudes* from around 1470 also showed more struggle than heroism).

The extremes of expression found in the Anghiari drawings are more pronounced than those of, for instance, the early *Adoration of the Magi*. Probably the artist was taking into consideration the distance at which the Anghiari figures would have been viewed, as had Verrocchio in his equestrian monument; Colleoni's fierce scowl verges on caricature (Fig. 12). But for all that Leonardo's warrior's face is distorted, it is not caricatured, but rather wracked with pain and extreme effort. Leonardo is usually credited with the invention of caricature, and rightly so, but his caricatures did not so much develop out of his studies of expression as out of the basic quandary evident in the *Last Supper* project: the dichotomy between beauty and ugliness. Leonardo's great insight was to see them as extreme elements on the same scale, like youth to age, or light to dark. Beauty and ugliness were not opposites, but different qualities of the basic human form (Fig. 13). Shifting the proportions and details of the features would transform them from beautiful to ugly. Later caricatures, those of Gianlorenzo Bernini, for instance, were often done to make amusing exaggerations of characteristic features or expressions. Leonardo's were done for the sake of exploring the sensation of horror, that is to expose the ugliness of nature rather than the faults of a particular person.

Horror that was not directed towards the pious fear of hell was unusual for the period. The passage in the notebooks in which Leonardo described the stupefaction he felt at a certain cavern he discovered while walking is as notable in the annals of the development of Western sensibility as the more famous description by Petrarch of his feelings on climbing Mount Ventoux in Provence, in April 1336. Petrarch's description is famous for its mingling of a newly awakening sensitivity to the beauties of the natural world with traditional religiosity. Leonardo's more private writing anticipates the rediscovery of the aesthetics of the sublime, that mixture of fear and awe inspired by extraordinary natural phenomena which was famously described by the Greek author Longinus. Leonardo wouldn't have known Longinus's treatise, but he independently apprehended a fearsome and even menacing quality in nature systematically overlooked by those who understood nature more conventionally as God's creation and a demonstration of his goodness. In general, Leonardo seems not to have shared the normal religious attitudes of his time. Vasari was careful to include a description of Leonardo's religious devotion on his deathbed (after having described him in the 1550 edition as more a philosopher than a Christian). In later times, the lack of obvious piety on Leonardo's part didn't damage his reputation with nineteenth-century historians who were themselves areligious.

No one at this time could dare to be known to be an atheist, any more than one could be blatant about a homosexual orientation. What is clear about Leonardo and religion is that he was curious about nature as a bivalent entity, as destructive as it was creative, as given to ugliness as to beauty, as horrible as it was admirable. It may not be

entirely unconnected that he was willing to work for unscrupulous patrons such as Duke Ludovico and Cesare Borgia. He may well have devised for himself a more complex moral, as well as aesthetic, understanding of the universe than most of his contemporaries – with the notable exception of Niccolò Machiavelli, a Florentine compatriot. Leonardo seized any opportunity to devise war machines and to plot the trajectories of missiles, problems that interested him a good deal (Fig. 14). Filippo Brunelleschi and Michelangelo may have been of more practical use to the governments they helped in time of war; in any case, Leonardo's military interests were not unusual for an artist of his time. Both of Leonardo's most warlike patrons failed spectacularly, so any help they may have had from Leonardo ultimately didn't do them much good. These investigations never made Leonardo rich, though the recrimination that has come down to us, jotted in the notebooks, is specifically against the Medici: 'The Medici made me and destroyed me.' He may have been sent to Milan as part of Lorenzo il Magnifico's diplomacy, and he jotted this line in Rome after the death of his patron Giuliano in 1516. In a more minor aspect of engineering, Leonardo famously made a lion that could walk a few steps, and whose breast then spilt out lilies in honour of the French. Valued at court for his clever conversation as well as his inventions, he was neither courtier nor servant, neither humanist nor buffoon, but something altogether new and different, an artist in residence.

Especially after the *Last Supper*, Leonardo didn't divide his compositions into visual dichotomies of good and evil, beautiful and ugly, or even male and female. A figure like the late *Saint John the*

Fig.13
Drawing of Two Heads in Profile and Studies of Machines
December 1478. Pen and ink, 20.2 × 26.6 cm.
Gabinetto dei Disegni e delle Stampe, Galleria degli Uffizi, Florence

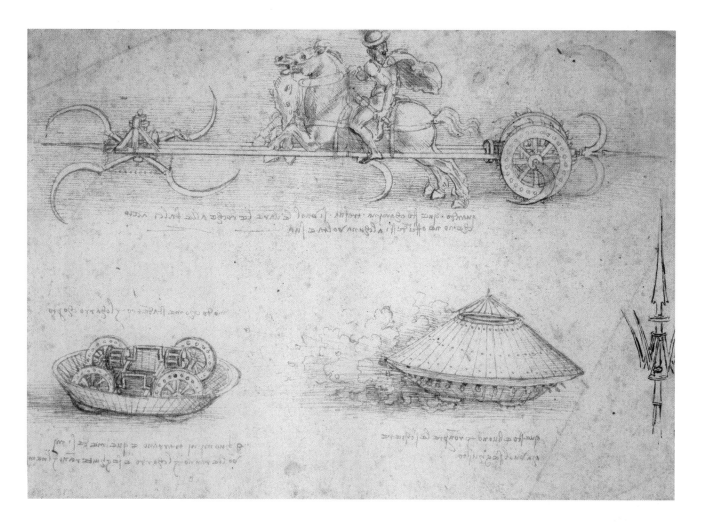

Fig.14
Design for a Scythed Chariot
and Armoured Car (?)
c.1485–8. Pen and ink,
17.3 × 24.6 cm.
British Museum, London

Baptist (Plate 48) was presumably meant to seem more holy because he approached the sexlessness of the angels. Leonardo was interested, on the one hand, in sheer power, and on the other, in that spiritual quality called grace. The Christ of the *Last Supper* required both, and the juxtaposition of long curling hair with the monumental architecture of the windows as framework was intended to achieve this complex effect. Leonardo had a taste, unusual for his time, for craggy mountains, hard and huge, yet when seen at a great distance, melted in blue haze. They appear in the distance, out the windows of the Upper Room, as indeed the Alps lie not far north of Milan. But even before Leonardo went to Milan, he included mountains in his paintings, much wilder mountains than the Apennines near Florence. In his last portrait, it is partly the mountains behind the *Mona Lisa* that invest her with a sense of potency, a strange latency that Walter Pater described so lushly: 'she is older than the rocks among which she sits; like the vampire, she has been dead many times, and learned the secrets of the grave; and has been a diver in deep seas … as Leda, was the mother of Helen of Troy, and, as Saint Anne, the mother of Mary; and all this has been to her but as the sound of lyres and flutes, and lives only in the delicacy with which it has moulded the changing lineaments, and tinged the eyelids and the hands.'

When Leonardo left Florence as a young man, his unfinished work was kept. After the Duke of Milan had been defeated and imprisoned, to die eight years later in a dungeon (oddly enough not far from where Leonardo would himself end his days as an honoured member of the French court), the Florentines welcomed him back with commissions, public and private. He served on the committee that had to decide what to do with Michelangelo's *David* when it was deemed too magnificent to position high on the cathedral where it would scarcely have been

noticed. He must have felt at least a twinge of envy thinking of how his own colossal sculpture had never been completed. While in Florence he undertook a cartoon (a large-scale preparatory design) showing the Virgin with the Child, her mother Saint Anne, and a lamb. For two days the public was allowed to view it, and according to a contemporary witness, everyone flocked to see the work, as if going to a solemn occasion ('*come si va a le feste solenni*'). This is sometimes described as the first art exhibition – perhaps a slight exaggeration, for the Florentines had long taken an informed interest in the visual arts. Still, it does seem as if the Florentine public took a more active interest in his work than the Milanese, Venetian or Roman, and not merely because he was a local boy.

Leonardo seems to have had no interest in politics (apart from that in city planning) and ultimately no home. He spent some of his declining years in Rome, under the patronage of the Medici Pope's brother. While there, he made many drawings, mostly in black chalk, of a deluge that is not biblical. Leonardo's *Deluge* series is based on several pages of text in his notebooks. He set himself the task of describing nature at its most powerful and most destructive, with cascades of water, still curling like hair but now crushing trees and even mountains into smithereens. They are in some sense the least naturalistic and the most abstract works of the period, though their subject is the workings of nature, albeit a nature more akin to the temporal than to the eternal. Leonardo had developed over the years a personal and unique sense of the interrelationship of text and image in his notebooks: jottings and sketches interspersed with more elaborate writings and drawings. One might look at his paintings and suppose erroneously that he was a relatively uninventive artist, always painting portraits and Madonnas. The notebooks, on the other hand, are rife with that distinctive quicksilver interplay between language and image. When he had a major painting to do, such as the *Last Supper* or the *Battle of Anghiari*, he wrote about what he imagined as well as sketching it. The *Deluge* drawings and writings represent the culmination of this skill, which in earlier years had often been directed towards fables or allegories. The early film director Sergei Eisenstein (1898–1948) called Leonardo's description of deluge an excellent shooting script.

The first artist for whom we have so personal a record of his private musings (including casual complaints about his misbehaving apprentices), Leonardo is also the last renowned artist for whom we have little reliable record of his appearance. Vasari used a profile drawing for his woodcut portrait in the 1568 edition of the *Lives*; that drawing is now in the Royal Collection, attributed to Leonardo's apprentice Francesco Melzi, who described him as having been like a father and to whom the artist left his notebooks. A red chalk drawing in Turin was labelled by an unknown hand with Leonardo's name (Fig. 15), and has often been taken to be a self portrait. That head also vaguely resembles that of Plato in Raphael's *School of Athens* – which no contemporary identifies as Leonardo, although other crypto-portraits are picked out. Neither of these bits of circumstantial evidence really warrants taking the drawing as a self portrait, and particularly not in the case of an artist who railed against the vain tendencies of artists: every painter paints himself ('*ogni dipintore dipinge sè*' – a saying sometimes credited to Cosimo de' Medici, grandfather of Lorenzo the Magnificent). We have to assume that Leonardo would also have avoided basing his favourite figural types on his own appearance. Barely sixty-seven years old when he died, Leonardo is said to have been very handsome – so handsome that people felt better for being around him, Vasari tells us, as well as being strong enough to bend a horseshoe. He was, in a word, impressive.

Fig. 15
Head of a Bearded Man
(known as 'Self Portrait')
*c.*1510–15 (?). Red chalk,
33.3 × 21.5 cm.
Biblioteca Reale, Turin

The Renaissance was the first period in which it became a recognized social pattern to rise from humble origins to greatness through education and hard work. Leonardo, although illegitimate, had the advantage of belonging to a family of higher social rank than that of most artists of the time. Very industrious, he was also highly capable of being distracted. His efforts at writing various treatises came to nothing, at least not for centuries. Many of his paintings were left unfinished; his great equestrian project was never completed, though the fault may have been partly his patron's. Leonardo regarded Duke Ludovico as someone whose projects had ended in failure; he seems not to have thought of himself that way. He had a reputation for slowness, though. Matteo Bandello, a well-known Milanese writer, described how Leonardo would come to the scaffolding for the *Last Supper*, stare for hours criticizing it to himself, and then leave without lifting a brush. On other days he would work throughout the daylight, never stopping for refreshment. Vasari lamented Leonardo's dilatoriness, and reported how, when he was commissioned to make a painting in Rome, late in life, he began by experimenting with varnishes, at which Pope Leo X exclaimed with exasperation that the man would never finish, since he started thinking about the end when he ought to have been planning the beginning. Leonardo didn't own much and worked little, remarked Vasari in an uncharacteristically frank moment, before going on to say that he somehow managed to live very well.

Although he was the earliest of the High Renaissance artists, his style is in some ways the closest to the Baroque that would follow. The extreme grimace of the Anghiari warrior takes us to the brink of Bernini's wincing *David* in marble, and the soft flesh, taste for enveloping shadows and panoramic sense of landscape all have close parallels in paintings by Baroque artists, who admired Correggio, who in turn had learned much from Leonardo. Not by mere coincidence did the Baroque revival begin in northern Italy, where Leonardo's naturalism continued to be esteemed.

Leonardo grew up during a relatively fallow spell within the glory period of Florentine art, remained remarkably unproductive throughout his life at least by the usual measures, and yet was recognized both during his life and long afterwards as a galvanizing figure. 'Truly amazing and heavenly', as Vasari called him, Leonardo succeeded in many things. He also failed in many things. Yet ultimately his failures belong among his achievements. As he himself explained, neither avarice nor negligence impeded him, but only lack of time, that 'exhauster of everything'. Since Leonardo, or at least since his reputation was revived by Jules Michelet, our concept of creative freedom has included the freedom to fail. Leonardo never conquered the problem of flight, among others, but we honour him for his aspiration, his imagination and the sustained effort of his pioneering thought.

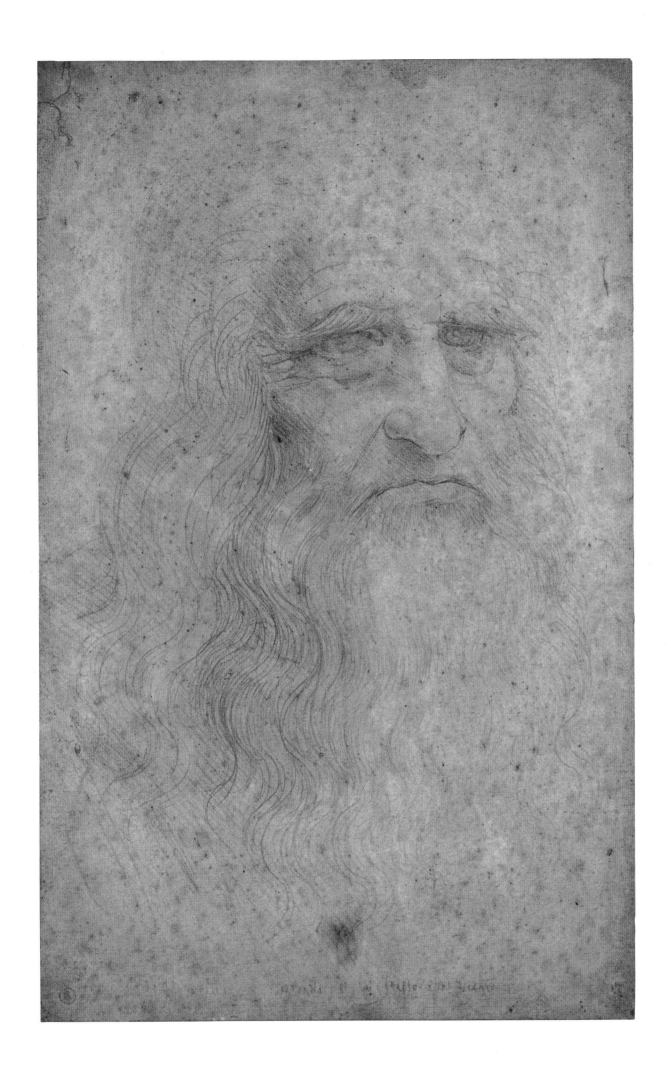

Outline Biography

1452 Leonardo da Vinci born on April 15 in Vinci, near Florence, illegitimate son of a notary, who does not have any other children for many years and brings Leonardo into his household. Mother, Caterina, may appear later in his life (d.1494?).

1472 Pays dues in Compagnia di San Luca, a painters' guild.

1476 Anonymous accusation of sodomy, not prosecuted; Leonardo is described as being in Verrocchio's workshop.

1483 April. Documented in Milan.

1493 A model of the equestrian statue in honour of Francesco Sforza, the duke of Milan is displayed.

1494 Ludovico usurps the dukedom and appropriates the bronze intended for the horse to make cannon.

1499 Ludovico deposed; Louis XII of France in power.

1500 April. Leonardo is in Florence, after stopping in Venice.

1502 Architect and engineer to Cesare Borgia, returns to Florence by February 1503.

1503 October. Commission for *Battle of Anghiari*. Works at Santa Maria Novella; transfers to Palazzo della Signoria in 1505.

1504 Death of Leonardo's father, leaving ten sons and two daughters. Leonardo omitted from the will, though not from his uncle's, three years later.

1506–7 Leonardo travels between Florence and Milan. Francesco Melzi joins his studio.

1508 Leaves Florence for Milan, where he remains until September 1513.

1513 October. Visits Florence on his way to Rome, where he is housed by Giuliano de' Medici, Duke of Nemours, in the Belvedere.

1516 17 March. Giuliano de' Medici, brother of the Pope and his patron, dies. His tomb in Florence is later designed by Michelangelo.

*c.*1517 Removes to Amboise as first painter and engineer to Francis I, King of France.

1519 23 April. Leonardo draws up will, leaving manuscripts and drawings, his clothes, his pension and other moneys to Francesco Melzi, nobleman of Milan and his executor. Two apprentices were each left half of his vineyard in Milan. Melzi returned to Milan, where he was visited by Vasari, and died around 1570.

1519 2 May. Dies at Amboise, with (according to Vasari) Francis I holding up his head to ease his discomfort (although the king is actually recorded as being elsewhere on this day). His tomb is destroyed in religious wars and the church in which it was housed is torn down in 1808.

1550 Vasari's publishes first edition of the *Lives*, with Leonardo cast as first 'modern' artist.

Select Bibliography

Carmen Bambach (ed.), *Leonardo da Vinci, Master Draftsman*, exhibition catalogue, Metropolitan Museum of Art, New Haven, 2003

Andrea Bayer, *Painters of Reality: The Legacy of Leonardo and Caravaggio in Lombardy*, exhibition catalogue, Metropolitan Museum of Art, New Haven, 2004

David Alan Brown, *Virtue and Beauty: Leonardo's 'Ginevra de' Benci' and Renaissance Portraits of Women*, exhibition catalogue, National Gallery of Art, Princeton, 2001

Kenneth Clarke, *Leonardo da Vinci*, first published 1939, revised edition with Martin Kemp, Harmondsworth, 1989

Martin Clayton, *Leonardo da Vinci, The Divine and the Grotesque*, exhibition catalogue, The Queen's Gallery, London, 2002

Idem, with Ron Philo, *Leonardo da Vinci, The Mechanics of Man*, Los Angeles, 2010

William Emboden, *Leonardo da Vinci on Plants and Gardens*, Portland, Or., 1978

Patricia Emison, *The Italian Renaissance and Cultural Memory*, Cambridge, 2011

Sigmund Freud, *Leonardo da Vinci: A Study in Psychosexuality*, tr. A. A. Brill, New York, 1947 (1910)

Ludwig Heydenreich, *Leonardo: The Last Supper*, New York, 1974

Kenneth Keele, *Leonardo da Vinci's Elements of the Science of Man*, London, 1983

Martin Kemp, *Leonardo*, Oxford, 2004

Pietro Marani, *Leonardo da Vinci: The Complete Paintings*, New York, 2000

Pietro Marani and Pinin Brambilla Barcilon, *Leonardo: The Last Supper*, tr. Harlow Tighe, Chicago, 2001

Walter Pater, *The Renaissance: Studies in Art and Poetry*, Oxford, 1986 (1873)

Carlo Pedretti, *Leonardo, Architect*, tr. Sue Brill, New York, 1981

Idem (ed.), *The Literary Works of Leonardo da Vinci*, 2 vols, Berkeley, 1977

A. E. Popham, *The Drawings of Leonardo da Vinci*, London, 1964

Gary Radke, *Leonardo da Vinci and the Art of Sculpture*, exhibition catalogue, High Museum of Art, New Haven, 2009

Jean Paul Richter (ed.), *The Notebooks of Leonardo da Vinci*, 2 vols, New York, 1970

Janice Shell and Grazioso Sironi, 'Cecilia Gallerani: Leonardo's Lady with an Ermine', *Artibus et Historiae*, XIII, 1992, 47–66.

Idem, 'Salai and Leonardo's Legacy,' *Burlington Magazine*, CXXXIII, Feb. 1991, 95–108

A. Richard Turner, *Inventing Leonardo*, New York, 1993

Giorgio Vasari, *The Lives of the Artists*, trs Julia and Peter Bondanella, Oxford, 1991

Carlo Vecce, *Leonardo*, Rome, 1998

Emanuel Winternitz, *Leonardo da Vinci as a Musician*, New Haven, 1982

Frank Zöllner, *Leonardo da Vinci, 1452–1519: The Complete Paintings and Drawings*, Cologne, 2003

List of Illustrations

Colour Plates

1. Landscape of Arno Valley, 5th August 1473
 1473. Pen and ink, 19 × 28.5 cm.
 Gabinetto dei Disegni e delle Stampe, Galleria degli
 Uffizi, Florence

2. Detail of Fig. 16

3. Drapery Study with Kneeling Figure
 Early 1470s. Metalpoint and black chalk on red
 prepared paper heightened with white, 25.8 × 19.5 cm.
 Gabinetto delle Stampe, Fondo Corsini, Rome

4. Drapery for the Legs of a Seated Figure
 c.1470s. Tempera with white heightening on linen,
 26.6 × 23.3 cm. Musée du Louvre, Paris

5. The Annunciation
 c.1472. Oil and tempera on poplar, 100 × 221.5 cm.
 Galleria degli Uffizi, Florence

6. Warrior with Helmet and
 Breastplate in Profile
 c.1475–80. Silverpoint on cream-coloured prepared
 paper, 28.7 × 21.1 cm. British Museum, London

7. Portrait of Ginevra de' Benci
 c.1478? Oil on poplar, 38.8 × 36.7 cm.
 National Gallery of Art, Washington, DC

8. Madonna with a Flower
 (The Benois Madonna)
 c.1480. Oil on wood, transferred to canvas,
 48 × 31 cm. The State Hermitage Museum,
 St Petersburg

9. The Adoration of the Magi
 1481–2. Oil on wood, 246 × 243 cm.
 Galleria degli Uffizi, Florence

10. Detail of Plate 9

11. Perspective Study for the Background
 of the Adoration of the Magi
 1481. Pen and ink over metalpoint with some
 wash, 16.5 × 29 cm. Gabinetto dei Disegni
 e delle Stampe, Galleria degli Uffizi, Florence

12. Portrait of a Musician
 c.1482–5. Oil on wood (walnut?), 44.7 × 32 cm.
 Pinacoteca Ambrosiana, Milan

13. An Allegory with Fortune (An Angel
 Placing a Shield on a Trophy and Separate
 Studies of the Angel)
 c.1485. Pen and ink and brown wash over a drawing
 with a stylus, 24.9 × 20.1 cm.
 British Museum, London

14. Saint Jerome
 c.1485? Oil and tempera on walnut,
 103 × 75 cm. Musei Vaticani, Vatican City

15. The Virgin of the Rocks (Virgin and Child
 with the Infant Saint John and an Angel)
 c.1483–4. Oil on wood, transferred to canvas in 1841,
 199 × 122 cm. Musée du Louvre, Paris

16. Detail of Plate 15

17. Study for the Sforza Monument
 c.1485–90. Metalpoint on blue prepared paper,
 15.2 × 18.8 cm. Royal Collection, Windsor

18. View and Plan of a Square Church with
 a Central Dome and Four Cupolas
 1488–90. Pen and ink, 23 × 16 cm.
 Bibliothèque nationale de France, Paris

19. Portrait of Cecilia Gallerani
 (Lady with an Ermine)
 1489–90. Oil on walnut (inscription added much
 later), 54.8 × 40.3 cm. Muzeum Narodowe, Kraków

20. Anatomical Study of the Human Skull
 in Side View, showing the Eye Sockets
 and Maxillary Sinus
 1489. Pen and brown ink over black pencil,
 18.8 × 13.4 cm. Royal Collection, Windsor

21. Studies of Hands and Arms
 c.1490. Metalpoint with white heightening over
 charcoal on prepared buff paper, 21.5 × 15 cm.
 Royal Collection, Windsor

22. Five Half-Length Figures
 c.1490. Pen and ink, 26 × 20.5 cm.
 Royal Collection, Windsor

23. Study of Horse from Profile,
 Three-Quarters, and Frontal Views
 c.1490. Metalpoint on blue prepared paper,
 21.2 × 16 cm. Royal Collection, Windsor

24. Allegory with Eagle and Mammal, Probably a Wolf
*c.*1495. Red chalk on brown-grey prepared paper, 17 × 28 cm. Royal Collection, Windsor

25. Portrait of an Unknown Woman ('La Belle Ferronière' *or* Portrait of Lucrezia Crivelli)
*c.*1497? Oil on walnut, 63 × 45 cm. Musée du Louvre, Paris

26. The Last Supper
*c.*1494–7. Tempera and oil on plaster, 4.6 × 8.8 m. Santa Maria delle Grazie, Milan

27. Study for the Last Supper (Saint James the Elder) and Architectural Sketches
*c.*1495. Red chalk, pen and ink, 25.2 × 17.2 cm. Royal Collection, Windsor

28. Sala delle Asse
*c.*1498. Tempera on plaster. Castello Sforzesco, Milan

29. Study of a Rearing Horse
*c.*1503. Pen and ink and red chalk, 15.3 × 14.2 cm. Royal Collection, Windsor

30. A Copse of Trees
*c.*1500–10. Red chalk, 19.1 × 15.3 cm. Royal Collection, Windsor

31. The Virgin and Child with Saint Anne and John the Baptist
*c.*1500. Black chalk and touches of white chalk on brownish paper, mounted on canvas, 141.5 × 104.6 cm. National Gallery, London

32. Detail of Plate 31

33. Portrait of Lisa Gherardini, Wife of Francesco del Giocondo (Mona Lisa *or* La Gioconda)
1503–6. Oil on poplar, 77 × 53 cm. Musée du Louvre, Paris

34. Detail of Plate 33

35. Study for Kneeling Leda
Begun *c.*1504. Pen and brown ink, brown wash over black chalk (inscribed 'leonardo da vinci' lower right by a later hand), 16 × 13.7 cm. The Devonshire Collection, Chatsworth, Derbyshire

36. Studies of Women's Hair
*c.*1504–6. Pen and ink over black chalk, 20 × 16.2 cm. Royal Collection, Windsor

37. Star of Bethlehem (*Ornithogalum Umbrellatum*) and Other Plants
1505–08. Pen and ink over red chalk, 19.8 × 16 cm. Royal Collection, Windsor

38. Study of the Heads of Two Soldiers
1503/4. Black and red chalk over metalpoint, 19.1 × 18.8 cm. Szépművészeti Múzeum, Budapest

39. The Madonna and Child, with Saint Anne and Lamb
*c.*1510–13. Oil on poplar, 168 × 130 cm. Musée du Louvre, Paris

40. Leonardo and Workshop The Virgin of the Rocks
*c.*1495–9 and 1506–08. Oil on poplar, 189.5 × 120 cm. National Gallery, London

41. Detail of Plate 40

42. A Branch of Blackberry
*c.*1505–10. Red chalk with touches of white heightening on pale red prepared paper, 15.5 × 16.2 cm. Royal Collection, Windsor

43. Study of Mountains
*c.*1510. Red chalk on pale red prepared paper, 15.9 × 24 cm. Royal Collection, Windsor

44. Embryo in Uterus
*c.*1510–13. Pen and ink and wash over red and traces of black chalk, 30.4 × 22 cm. Royal Collection, Windsor

45. Sheet of Studies of Horses, a Cat and Fight with a Dragon
*c.*1508. Pen and ink over black chalk, 29.8 × 21.2 cm. Royal Collection, Windsor

46. Deluge (Tempest over Horsemen and Trees with Enormous Waves)
*c.*1517–18. Black chalk, pen and ink and wash with touches of white heightening on grey prepared paper, 27 × 40.8 cm. Royal Collection, Windsor

47. Deluge over the Sea
*c.*1515. Black chalk, 15.8 × 21 cm. Royal Collection, Windsor

48. Saint John the Baptist
*c.*1515. Oil on walnut, 69 × 57 cm. Musée du Louvre, Paris

Text Figures

1. J.-A.-D. Ingres (1780–1867)
 Death of Leonardo da Vinci
 1811. Oil on canvas, 40 × 50.5 cm.
 Musée du Petit Palais, Paris

2. Studies of a Child with a Cat
 1478–81. Pen and ink, 20.6 × 14.3 cm.
 British Museum, London

3. Half-length Portrait of a Young
 Woman in Profile (Isabella d'Este)
 c.1499/1500. Black and red chalk on paper,
 pricked, 63 × 46 cm. Musée du Louvre, Paris

4. Andrea del Verrocchio (c.1435–88)
 Portrait Bust of a Lady with Flowers
 1475–80. Marble, 61 cm height.
 Museo Nazionale del Bargello, Florence

5. Study of the Hanged Bernardo di
 Bandino Baronceli, December 1479
 1479. Pen and ink, 19.2 × 7.8 cm.
 Musée Bonnat, Bayonne

6. A Young Woman Pointing
 c.1513. Black chalk, 21 × 13.5 cm.
 Royal Collection, Windsor

7. Allegories of Pleasure and Pain
 and of Envy
 c.1483–5. Pen and ink, 21 × 29 cm.
 Christ Church, Oxford

8. The Sexual Act in Vertical Section
 c.1490. Pen and brown ink, 27.6 × 20.4 cm.
 Royal Collection, Windsor

9. The Proportions of the Human Figure
 (after Vitruvius)
 c.1490. Pen, ink and watercolour over metalpoint,
 34.4 × 24.5 cm. Gallerie dell'Accademia, Venice

10. Neptune with Four Seahorses (Quos ego)
 c.1502–4. Black chalk, 25.1 × 39.2 cm.
 Royal Collection, Windsor

11. Studies of Cats, a Dragon and
 Other Animals
 c.1517–18. Pen and ink and wash over black chalk,
 29.8 × 21 cm. Royal Collection, Windsor

12. Andrea del Verrocchio
 Equestrian Monument of Bartolommeo
 Colleoni (detail)
 c.1483–8. Bronze, 4 m height.
 Campo dei Santi Giovanni e Paolo, Venice

13. Drawing of Two Heads in Profile
 and Studies of Machines
 December 1478. Pen and ink, 20.2 × 26.6 cm.
 Gabinetto dei Disegni e delle Stampe,
 Galleria degli Uffizi, Florence

14. Design for a Scythed Chariot
 and Armoured Car (?)
 c.1485–8. Pen and ink, 17.3 × 24.6 cm.
 British Museum, London

15. Head of a Bearded Man
 (known as 'Self Portrait')
 c.1510–15 (?). Red chalk, 33.3 × 21.5 cm.
 Biblioteca Reale, Turin

Comparative Figures

16. Andrea del Verrocchio (c.1435–88)
 & Leonardo
 The Baptism of Christ
 Mid 1470s. Oil and tempera on poplar,
 180 × 151.3 cm. Galleria degli Uffizi, Florence

17. Reverse of Portrait of Ginevra de' Benci
 c.1478? Oil on poplar, 38.8 × 36.7 cm.
 National Gallery of Art, Washington, DC

18. Madonna and Child (Madonna of
 the Carnation)
 c.1476. Tempera (?) and oil on poplar (?),
 62.3 × 48.5 cm. Alte Pinakothek, Munich

19. Filippino Lippi (c.1457–1504)
 The Adoration of the Magi
 1496. Oil on panel, 258 × 243 cm.
 Galleria degli Uffizi, Florence

20. Six Studies of Figures
 c.1481. Pen and ink over metalpoint, 27.8 × 20.8 cm.
 Musée du Louvre, Paris

21. After Leonardo
Madonna of the Yarnwinder
*c.*1501–7 (?). Oil on wood (poplar?), 48.3 × 36.9 cm.
Collection of the Duke of Buccleuch & Queensbury,
Drumlanrig Castle, Scotland

22. Cola da Caprarola (1508–1604)
San Maria della Consolazione, 1508
Todi, Umbria

23. After Leonardo
Bust of a Young Woman with
a Garland of Ivy
1490–1510. Engraving lettered round the edge of the
circle 'ACHA LE VI' (Academia Leonardo da Vinci),
13.6 × 13 cm. British Museum, London

24. Wenceslaus Hollar (1607–1677)
'Divers Anticke Faces after Leonardo
da Vinci' 1666.
Etching, 5.8 × 5.5 cm. British Museum, London

25. Studies of the Proportions of a Horse's Leg
*c.*1485–90. Pen and ink, 25 × 18.7 cm.
Royal Collection, Windsor

26. Drawing of a Young Man in Costume with
a Lance in his Right Hand
*c.*1517–18. Pen and ink over black chalk,
27.3 × 18.3 cm. Royal Collection, Windsor

27. Giovanni Pietro da Birago (active
1470–1513) after Leonardo
The Last Supper, with a Spaniel
*c.*1500. Engraving, 21.3 × 44 cm.
Metropolitan Museum of Art, New York

28. After Leonardo
Head of Saint John the Evangelist
1490s–1500s. Pencil, black chalk, pastel and
watercolour, 56.2 × 43.2 cm. Musées de Strasbourg

29. Sixth Knot
1490–1500. Engraving with the words 'Academia
Leonardi' broken up in six positions in the design,
and the word 'Vici' in the centre. 29.3 × 20.7 cm.
British Museum, London

30. Sala delle Asse, Castello Sforzesco, Milan

31. Raphael (1483–1520)
Leda and the Swan
*c.*1506. Pen and ink over chalk, 31 × 19.2 cm.
Royal Collection, Windsor

32. Studies of an Old Man and of
Swirling Water
*c.*1510. Pen and ink, 15.2 × 21.3 cm.
Royal Collection, Windsor

33. Francesco Melzi (1493–1570)
Flora
1520s, 76.5 × 63 cm.
The State Hermitage Museum, St Petersburg

34. Peter Paul Rubens (1577–1640)
Copy after Leonardo's Battle of Anghiari
*c.*1603. Black chalk, pen, ink, heightened with white
lead, reworked in watercolour, 45.2 × 63.7 cm.
Musée du Louvre, Paris

35. Study of the Drapery of a Figure Seated
to the Right
*c.*1501 or 1510/11(?). Black chalk, washed with Indian
ink and heightened with white, 23.1 × 24.6 cm.
Cabinet des Dessins, Musée du Louvre, Paris

36. Detail of Plate 40

37. Studies of Flowers
*c.*1483. Pen and ink over metalpoint, 18.3 × 20.3 cm.
Gallerie dell'Accademia, Venice

38. Anatomical Analysis of the Movements
of the Shoulder and Neck
*c.*1509/10. Pen, three shades of brown ink and wash
over black chalk, 29.2 × 19.8 cm.
Royal Collection, Windsor

39. Storm in an Alpine Valley
*c.*1508–10. Red chalk on paper, 19.8 × 15 cm.
Royal Collection, Windsor

40. Implements Rained Down on the Earth
from the Clouds
*c.*1498. Pen and ink, 11.7 × 11.1 cm.
Royal Collection, Windsor

41. Study for Saint John the Baptist
*c.*1476. Silverpoint on blue prepared surface,
heightened with white, 17.8 × 12.2 cm.
Royal Collection, Windsor

42. Giovanni Francesco Rustici (1474–1554)
Preaching of Saint John the Baptist
1506–11. Bronze, 2.65 m.
Battistero di San Giovanni, Florence

Landscape of Arno Valley, 5th August 1473

1473. Pen and ink, 19 × 28.5 cm. Gabinetto dei Disegni e delle Stampe,
Galleria degli Uffizi, Florence

Leonardo never signed a work of art and dated only this one, as though he wanted to be sure to remember the occasion. In the course of a seemingly casual walk on a summer's day, the twenty-one-year-old artist decided to try to capture the shimmering of leaves moving in the light, much like the *plein air* approach of the Impressionists four centuries later. He did this at a time when drawing meant for the most part studies of the posed human figure or else perspective constructions. Broken arcs of pen work translate the effect of blowing boughs; in the left foreground tight curls of pen work invigorate the page. The fields in the distance provide a sort of equivalent to the chequerboard pavements that helped establish perspective for interior scenes. In a Florence in which many painters began their artistic lives as apprentices to goldsmiths, trained for detail and precision, Leonardo's ability to see the whole picture as well as the detail, and to do so without falling back on bland generalizations of what he saw, was unmatched. He was a landscape painter in an era that had as yet no real use for that genre.

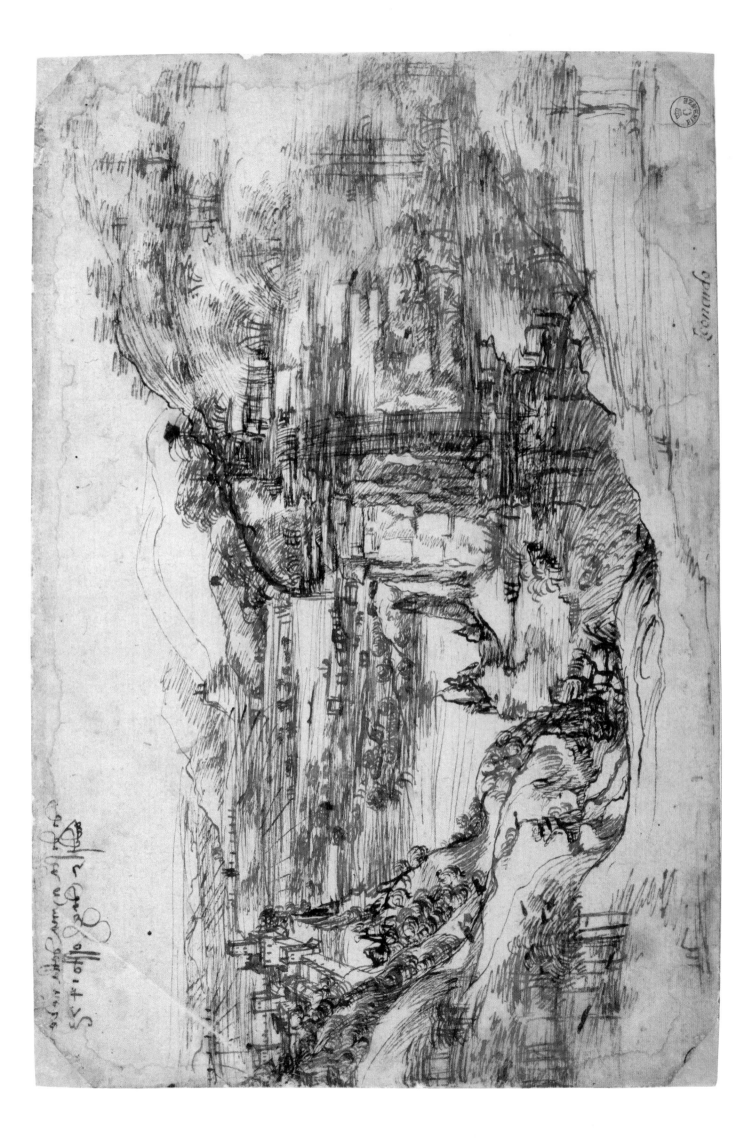

The Baptism of Christ (Detail)

Mid 1470s. Oil and tempera on poplar, 180 × 151.3 cm. Galleria degli Uffizi, Florence

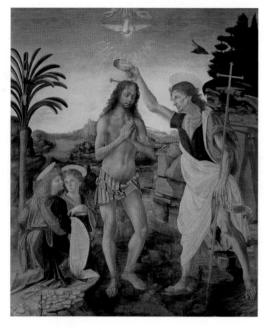

Fig. 16
Andrea del Verrocchio
(c.1435–88) & Leonardo
The Baptism of Christ
Galleria degli Uffizi, Florence

According to Vasari, when Verrocchio saw the difference between his angel (with hands folded) and that of his young pupil Leonardo (holding the clothes of Christ while he is baptized), he gave up painting for ever and confined his efforts to sculpture. The appearance of the two angels could support such a story – Leonardo's is like a poem next to Verrocchio's in prose; the problem is that Vasari describes Leonardo as a mere boy and the panel is usually dated to Leonardo's early adulthood. Still, the disparity in style may have signalled that it would soon be time for Leonardo to leave the workshop. The altarpiece, made for the Benedictine monks of San Salvi, is thought to have been the first large painting of this subject in Florence.

The twist of the head of the angel past profile, the glistening of the eyeballs, the shimmer of the light on the gold threads of the sleeve and the convincing complexity of the drapery folds over the leg all show the precocious beginnings of a style that soon no one would be able to match. Very seldom is the top side of a halo shown, but once the angel was positioned facing in and looking back, that was how the halo had to be delineated. Verrocchio's angel betrays the studio assistant who posed for him, whereas what Leonardo painted required equal measures of observation and imagination.

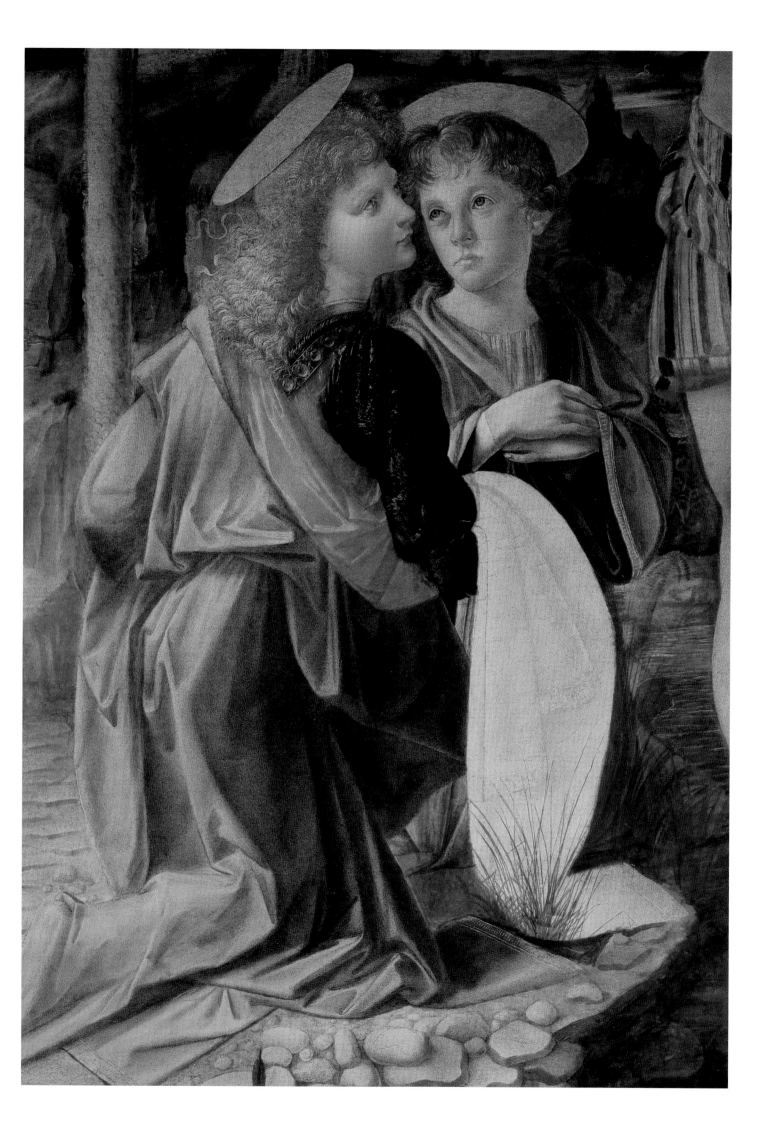

Drapery Study with Kneeling Figure

Early 1470s. Metalpoint and black chalk on red prepared paper heightened with white, 25.8 × 19.5 cm. Gabinetto Disegni e Stampe, Fondo Corsini, Rome

Apparently a study for a Virgin of the Annunciation, this may record an early idea for the Uffizi *Annunciation* (Plate 5) in which the two figures would more nearly have mirrored each other. Leonardo's attention lingered longer on the drapery than on the figure and especially on the parts with white heightening, on the folds falling in the front of the figure and fairly distinct from her form. Leonardo's willingness to work different parts of a drawing to such different degrees of finish was quite unusual. His extreme focus on an inanimate part of a composition aligns his vision with the Netherlandish tradition, to which he was particularly receptive. The huge triptych by Hugo van der Goes, the *Portinari Altarpiece*, arrived in Florence only after Leonardo had left; in Milan, court artist Zanetto Bugatto (d.1476) had trained with Rogier van der Weyden, who may himself have visited Italy in around 1450. Although Leonardo may have honed his taste for descriptive particulars with some help from the Netherlandish tradition, he was unique in combining that with highly expressive, in some cases downright energetic, movement.

4 Drapery for the Legs of a Seated Figure

*c.*1470s. Tempera with white heightening on linen, 26.6 × 23.3 cm.
Musée du Louvre, Paris

Vasari particularly praised – as miraculous – certain drawings Leonardo made on linen, worked in black and white with the tip of his brush, some of which Vasari himself owned. Leonardo would make clay figures and then drape them in order to make prolonged, patient study, presumably using an artificial and fairly constant light.

This arrangement of drapery has long been compared with that of the Virgin of the Uffizi *Annunciation* (Plate 5), though it may be that Leonardo consulted this study when he had that painting to do, rather than that this should be considered a preparatory study. In general his paintings benefited from his long-standing study of nature, rather than that he studied nature because of a particular task at hand.

This drawing once belonged to Everhard Jabach (1618–95), a wealthy banker who lived in Paris and acquired a legendary collection of drawings and paintings, many of which he was forced to sell to Louis XIV. Even after this reversal, he soon resumed collecting art and continued to do so until his death.

The Annunciation

*c.*1472. Oil and tempera on poplar, 100 × 221.5 cm. Galleria degli Uffizi, Florence

The Virgin is reading in a partially-enclosed garden, her chamber visible through the door. The soft, flowing fabric, the path meandering back through the landscape, the convincing structure and texture of the wings (before they were lengthened), and the complexity of petals in some of the flowers are traits retained in Leonardo's more mature style.

The strict profile, the sharply silhouetted trees and the starkness of the stone horizontals that function as transversal punctuation in the pictorial recession, as well as the *millefleurs* tapestry look of the grassy carpet, all mark this as early work. The Virgin with her elaborate lectern (which includes a circle inscribed in a square and perhaps the best claw feet ever painted) is highly reminiscent of Verrocchio's work, so it is usually supposed that this painting was done in the master's workshop, from the time Leonardo was in the process of becoming an independent painter.

The shape of the painting indicates that it was never used as an altarpiece. Fra Filippo Lippi (*c.*1406–69) had painted an *Annunciation* on an oblong panel twenty years earlier (now in the National Gallery, London), which is thought to have been hung over a door in the Medici Palace. Leonardo's is much wider. Perhaps the shape was his choice, as being appropriate for a kneeling and a seated figure who needed to be shown at some distance from one another. The painting entered the Uffizi in 1867 from the monastery of San Bartolomeo a Monte Oliveto.

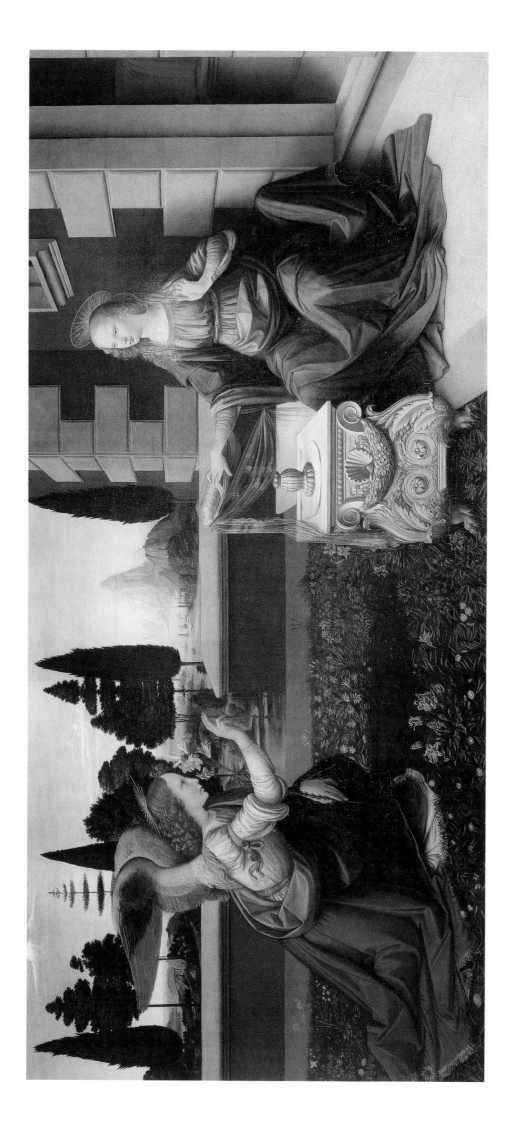

Warrior with Helmet and Breastplate in Profile

*c.*1475–80. Silverpoint on cream-coloured prepared paper, 28.7 × 21.1 cm.
British Museum, London

According to Vasari, Lorenzo de' Medici (Lorenzo the Magnificent) sent as diplomatic gifts to King Matthias Corvinus of Hungary a pair of bronze reliefs. These portrayed two great antagonists in antiquity, the young Alexander the Great and the mature Darius of Persia, whom Alexander defeated in 331 BC. Darius used scythe-equipped chariots, reports of which may have inspired some of Leonardo's sketches of armaments (see Fig. 14). Leonardo recorded a conversation in his notebooks, in which Corvinus explained to a poet that painting served a nobler sense (sight) and was more pleasurable because its harmonies were simultaneously apparent.

The reliefs sent to Hungary appear to be lost, though various marble and terracotta versions have come down to us. This drawing, which once belonged to the painter Thomas Lawrence (1769–1830), gives us Leonardo's reflection on their design. It is executed in his characteristic left-handed hatching. Derivative as it unashamedly is, it shows Leonardo's subtle adjustments: some to enhance the three-dimensionality of the image (from the wrinkles around the eyes to the decorative fringes of layered material, the hair at the top of the forehead, the double chin), some to deepen the characterization (ensuring, for instance, that the lion's head on the cuirass does not compete with the scowling face). The mixed bird/butterfly wing above the ears, as well as the helmet's bird-like beak, show every sign of being Leonardo's inventions. The delicacy of the metalpoint mark is as arresting as the ferocity of the man portrayed.

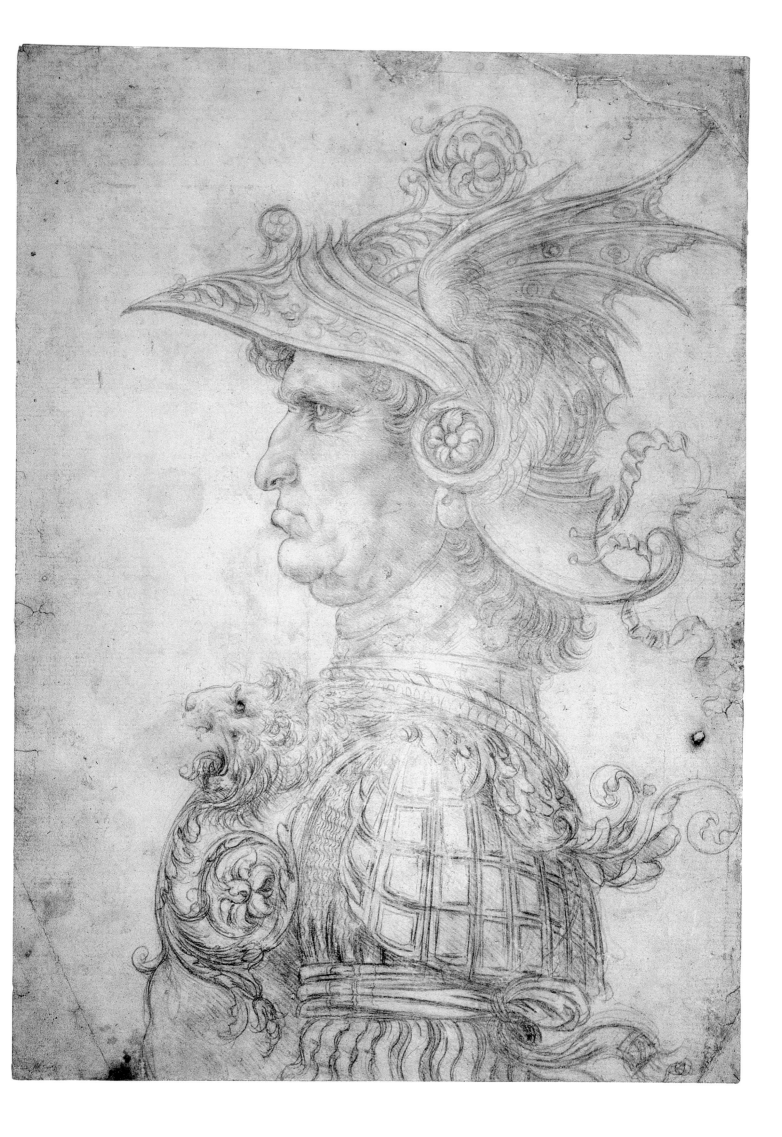

Portrait of Ginevra de' Benci

*c.*1478? Oil on poplar, 38.8 × 36.7 cm.
National Gallery of Art, Washington, DC

Fig. 17
Reverse of Portrait of
Ginevra de' Benci

Ginevra came from a wealthy Florentine family and was married at sixteen, in 1474, to a man fifteen years her senior, whose wife had recently died. Her grandfather flourished as an employee of Cosimo de' Medici's father and then of Cosimo himself. Her husband, who was in the cloth business, claimed at tax time in 1480 to be suffering financially, partly because of expenses pertaining to his ill wife. He died in 1505; she was buried at the nunnery heavily patronized by her family, Le Murate, in 1521.

The spiky foliage that forms a natural halo behind Ginevra is juniper, a visual pun on her name. In the distance of the landscape that recedes to the right, church towers can be seen. Although Ginevra looks out of the picture, at a time when profile portraits were just beginning to be displaced by the three-quarters view, her aspect is distinctly aloof. Her garb is remarkably plain; her porcelain perfection has not been presented in such a way as to assert high social status, only beauty. The simplicity of her attire, not least the black cloth draped over her shoulders, and a reference in two poems in her honour by Lorenzo de' Medici to her retreat from the evils of the city, have sparked the idea that, instead of a wedding portrait, we may have here a portrait intended to signal her religiosity.

The verso is painted to look like porphyry, a precious and very hard stone used by Leonardo's master Verrocchio on magnificent Medici tombs. It is adorned with three emblematic sprigs: laurel (to signify her poetic attainments, almost entirely lost to us), palm (associated with Christian virtue) and juniper. The inscription, meaning 'Beauty adorns Virtue', has been painted over an earlier version, 'Virtue and Honour'. The earlier motto was also used by Bernardo Bembo, who was linked with the married Ginevra in the Platonic pairings fashionable in Florence at the time, while he was ambassador there from Venice.

The only painting by Leonardo in the United States, it was acquired from Liechtenstein's Royal Collection in 1967 (the last Leonardo to come up for sale) and cleaned in 1991. The background foliage would originally have looked greener, and Ginevra's skin may not have been quite so pale. Even so, figure and background seem to have been colouristically harmonized, one with the other. The lower edge has been trimmed, presumably because of damage to the back of the picture and presumably also not so much as would greatly affect the primary image on the front. The panel must have been long enough to complete the emblematic branches on the back, but estimates of fifteen to twenty centimetres (six to eight inches) of loss seem excessive.

This is the first painting of Leonardo's maturity, in which he newly achieved astonishing effects from the oil medium, such as no one else had yet envisaged. The shining hair, seen both as individual strands and as massed locks; the shimmering water, bright in the distance of an axis that begins with her shadowed right shoulder; and the transparent chemise that both casts its shadow onto her fair skin and receives the shadow of the black stole: all these hallmarks of Leonardo's style emerge with this work, executed when he was in his twenties, perhaps not long before his departure for Milan.

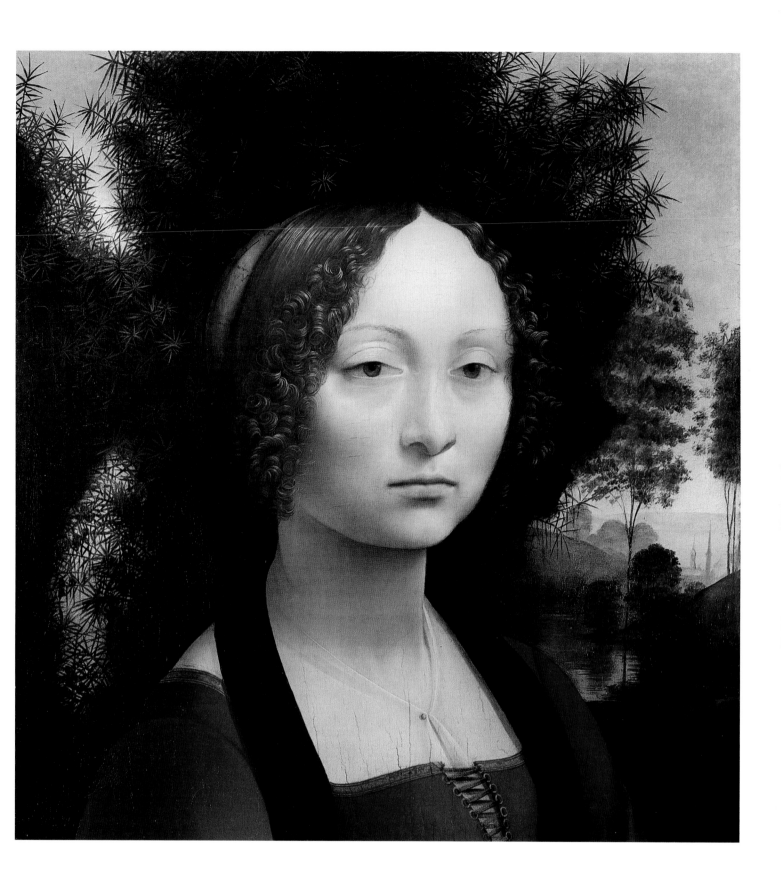

Madonna with a Flower (The Benois Madonna)

*c.*1480. Oil on wood, transferred to canvas, 48 × 31 cm.
The State Hermitage Museum, St Petersburg

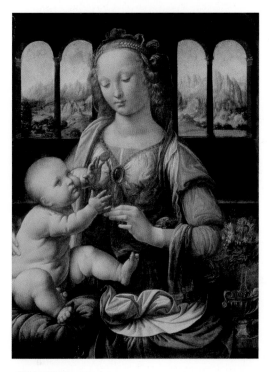

Fig.18
Madonna and Child
(Madonna of the Carnation)
*c.*1476. Tempera (?) and oil on
poplar (?), 62.3 × 48.5 cm.
Alte Pinakothek, Munich

With its charmingly girlish Madonna, this is Leonardo's most accomplished attempt at this central, simple and universally appealing subject of Renaissance art. He has subdued the colours of the clothing so that the faces and hands dominate. At the centre is the exchange of the small flower, which has been identified as a bitter herb of significantly cruciform shape. Leonardo still includes haloes, but ones more delicate than those of his teacher Verrocchio. The combination of blue and golden-orange was one he would return to again and again; in the drapery on the slightly diagonal leg, and especially in the tight braids that relax into looseness, the young artist can be seen developing his own distinctive set of motifs and forms. His pen drawings prove what we might otherwise infer – that he had studied mothers and naked infants from life, complete with squirming.

The reflective brooch has a correlate in the *Madonna of the Carnation* in Munich (and later, in the *Virgin of the Rocks*, Plates 15 and 40), but there it is augmented by a glass vase of flowers, and outside the window by blue and amber mountain ranges. The Munich painting was once attributed to Verrocchio, so indebted to his style is it. It may have been done in Verrocchio's workshop, in around 1476, but the tight braids, the fantastic mountains, the diaphanous veil and the blue and yellow colour of the drapery all assure us that this work is by Leonardo, who was in the process of developing his own distinctive style.

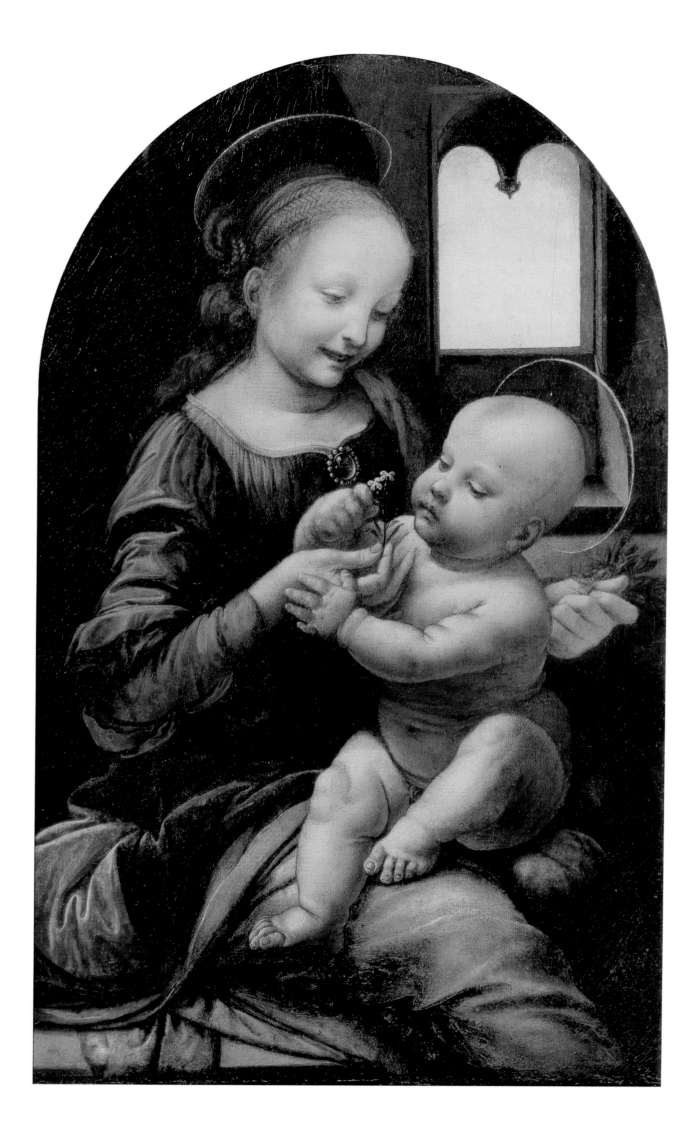

The Adoration of the Magi

1481–2. Oil on wood, 246 × 243 cm. Galleria degli Uffizi, Florence

In July 1481 Leonardo made a contract with the monks of San Donato near Florence to paint for them a panel for the high altar within two years, or at least thirty months. His father was notary for the monks, who had recently been left some land and instructions to commission an altarpiece and pay a girl's dowry out of the bequest.

When Leonardo left for Milan, the panel, still with underpaint only, was stored in the house of the Benci family; Leonardo shared books and interests with Ginevra's brothers. The monks then commissioned a new altarpiece from Filippino Lippi, installed in 1496 (Fig. 19).

The range in Leonardo's figural types is matched by the variety of expressions and poses, all of which are exceptionally energized. The figures are not only physically vibrant but seem mentally alive as well. Filippino's altarpiece is highly colourful to the point of seeming relatively disjointed; Leonardo had built a composition that had both movement and unity, one highly integrated in both line and lighting.

The square field is unusual, although it was imitated in Filippino's altarpiece and later by Raphael in his *Entombment* of 1507. The Virgin's head is at the centre of the panel. Two kings kneel on the left and one on the right; the trees on the right help maintain the balance of the composition and are themselves offset by the ruins in the left background.

Fig. 19
Filippino Lippi
(*c.*1457–1504)
The Adoration of the Magi
1496. Oil on panel, 258 × 243 cm.
Galleria degli Uffizi, Florence

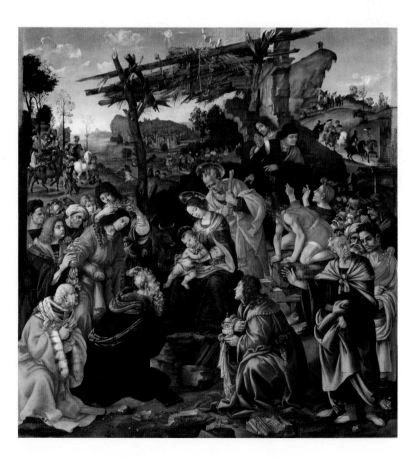

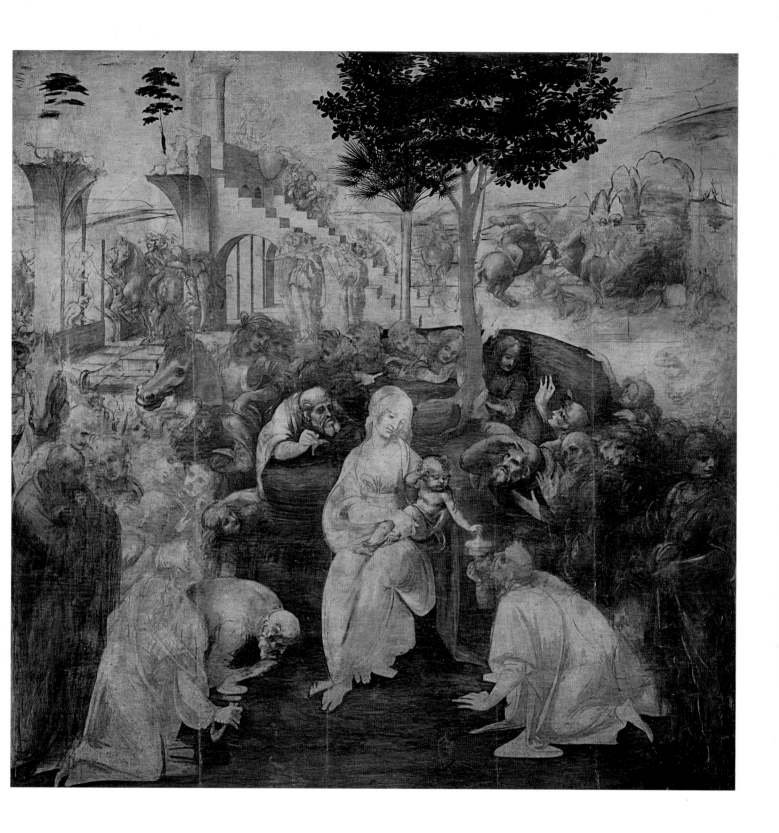

Galleria degli Uffizi, Florence

Fig. 20
Six Studies of Figures
c.1481. Pen and ink over
metalpoint, 27.8 × 20.8 cm.
Musée du Louvre, Paris

The subject of the Adoration of the Magi had long provided artists the opportunity to fill in a landscape with panoply and paraphernalia, though Leonardo's version shows an exceptional degree of variety and energetic action (see Plate 9). His love of sketching both figures and horses in stretching, straining poses finally had an outlet, for instance in the equestrian confrontation that fills in the right background. The contrast of spiky with soft foliage seen here was often favoured by Leonardo.

The particular glory of the panel is the supporting cast: the ring of attendants anticipates Raphael's Stanza della Segnatura compositions in the density with which highly characterized figures are packed. The figure on the far right who looks out while pointing into the picture space has a cousin in Raphael's *Disputa*. Young and old, attentive and distracted, concerned or simply admiring, the men are both more active and more psychologically vibrant than the sweet but bland Virgin. The kings too are overshadowed by their entourages, whose bending, twisting postures and deep sunken eyes, whose frowns and highly mobile gestures grasp our attention more than those of the lead characters. By the time he worked on the *Last Supper* (Plate 26), Leonardo had solved some of the problems he encountered here: he had learned better to incorporate his careful observation of interesting faces into the stock lead characters he was expected to portray.

Studies in pen and ink over metalpoint (Fig. 20) show Leonardo trying to capture the movements by which the wonder of the occasion is expressed – rather than a stop-motion approach, as is still evident in the figure on the upper left. Leonardo tries to imply time before and after what he actually draws by pinpointing a moment in the midst of gradual, graceful movement. 'That figure is most praiseworthy,' he wrote, 'which by its action best expresses the emotion in its soul.' He thereby concisely articulated a new way of thinking about visual art.

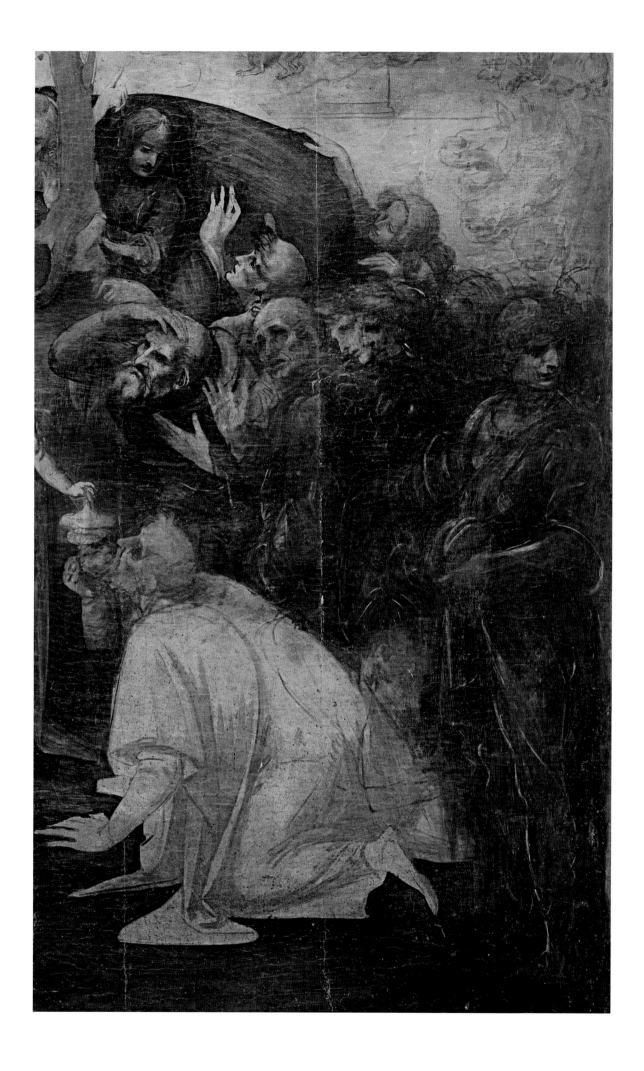

11 Perspective Study for the Background
 of the Adoration of the Magi

1481. Pen and ink over metalpoint with some wash, 16.5 × 29 cm.
Gabinetto dei Disegni e delle Stampe, Galleria degli Uffizi, Florence

Leonardo used drawings to measure proportions of the human body, the
head, or alternatively to analyse the proportions of a horse. The availability
of paper now enabled artists to think out their compositions in much more
detail ahead of painting; in this case, Leonardo carefully worked out the
systematic linear perspective construction of the architectural elements of
his *Adoration of the Magi* (Plate 9). At this stage he envisioned architecture
as tying together the whole of the background and, especially on the
right, drew in more classical architecture than appeared on the panel. The
vanishing point was eventually hidden behind the tree trunk, and the great
slanted roof outlined in the drawing never materialized. The architecture
became stranger, more ruined; the staircases slid closer together. Scenes of
the Adoration customarily included fairly substantial architecture, often
noticeably antique in style, as well as featuring more or less unruly retinues.
This drawing shows us Leonardo starting out with a more conventional
background, complete with camel, though with an exceptionally ambitious
perspective scheme. He revised this on the panel in favour of proto-Piranesi
screens of architectural fragments, thereby delimiting a disturbed pictorial
world rather than a highly ordered one.

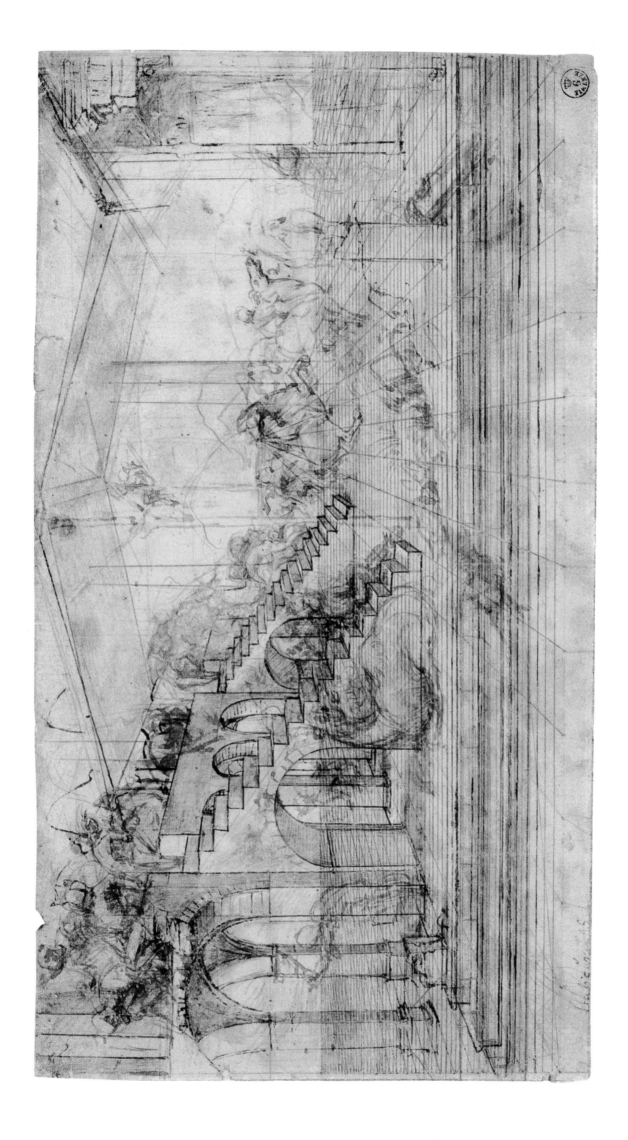

Portrait of a Musician

*c.*1482–5. Oil on wood (walnut?), 44.7 × 32 cm.
Pinacoteca Ambrosiana, Milan

Leonardo taught himself to paint the moisture of the eye and the light reflected on its surface. Together with the irregularity of the curls as they fall and catch the light, both individual strands and clumps of hair, and the soft-edged shadows on the lower cheeks, not to mention the apparent incompleteness of the clothing, the painting displays many characteristics typical of Leonardo's work. Before a cleaning in 1905 revealed the hand holding a sheet of music, the sitter was sometimes thought to be the Duke of Milan, an idea now long since abandoned. We have no other male portraits by Leonardo, despite his numerous male patrons. Josquin des Prez and Franchino Gaffurio, both prominent musicians at the court, have been proposed as sitters, as have still others. What we do know is that Leonardo was himself a musician, counted musicians among his friends, and called music the 'sister of painting'.

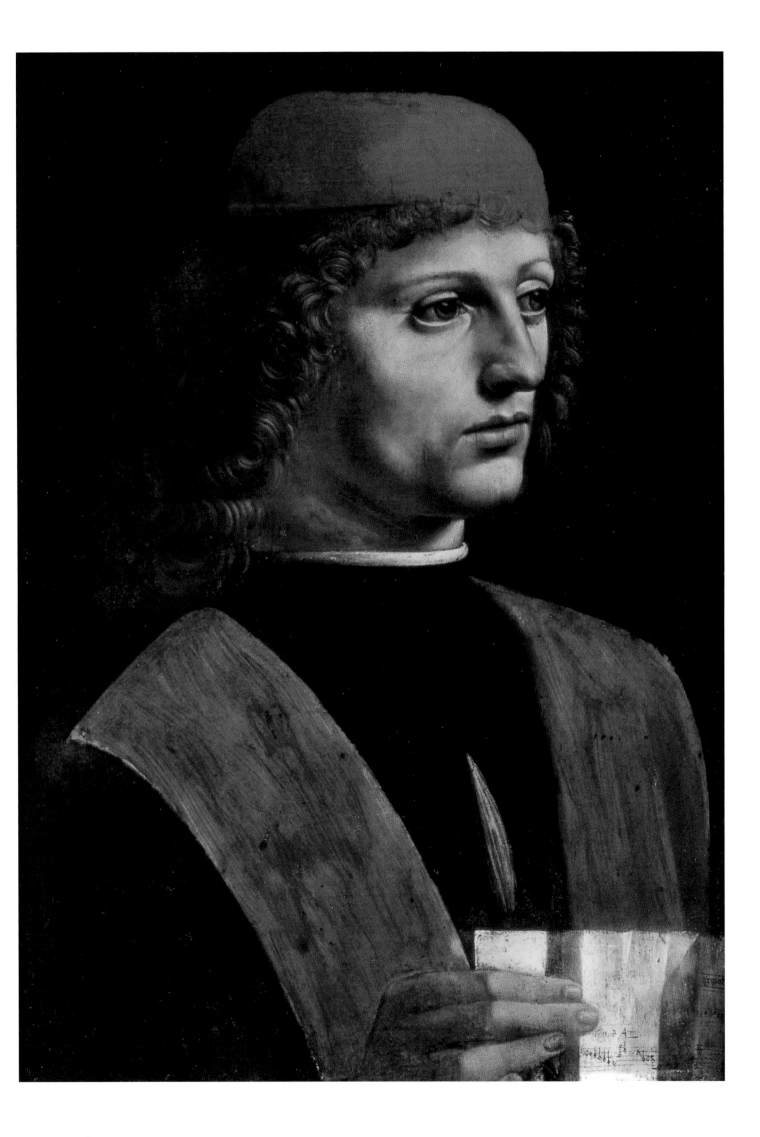

13 An Allegory with Fortune (An Angel Placing
a Shield on a Trophy and Separate Studies of
the Angel)

c.1485. Pen and ink and brown wash over a drawing with a stylus, 24.9 × 20.1 cm.
British Museum, London

Although he didn't paint allegories, Leonardo liked to draw them. He also
probably helped to stage allegorical scenes as court entertainments. The
glory of this sheet is the Victory with streaming hair in the upper left, all
motion and lightness, achieved partly by freely disposed line and partly
by the vibrant contrast of dark and light. The spread arms and legs balance
each other as she both flies and balances, in a way that faintly recalls the
bronze *Putto with a Dolphin* (Palazzo della Signoria, Florence) by his teacher
Verrocchio. The head to the right, with the hair now streaming in front of
the face, appears to be a more worked-up version of the figure in the bottom
right – unusually for Leonardo, a half-naked woman. This masterpiece of
succinctness, in broad, almost Rembrandtesque strokes, suggests the type
of Occasio, whose forelock must be grabbed before she has gone by and the
chance is lost. She reaches toward the pile on the bottom left, which seems
to be a trophy, or a monument of the insignia and arms of the vanquished,
appropriate enough for these personifications, whether they be Occasio,
Fortuna or Victory.

 Leonardo never signed his works; the signature, bottom right, was
presumably added considerably later.

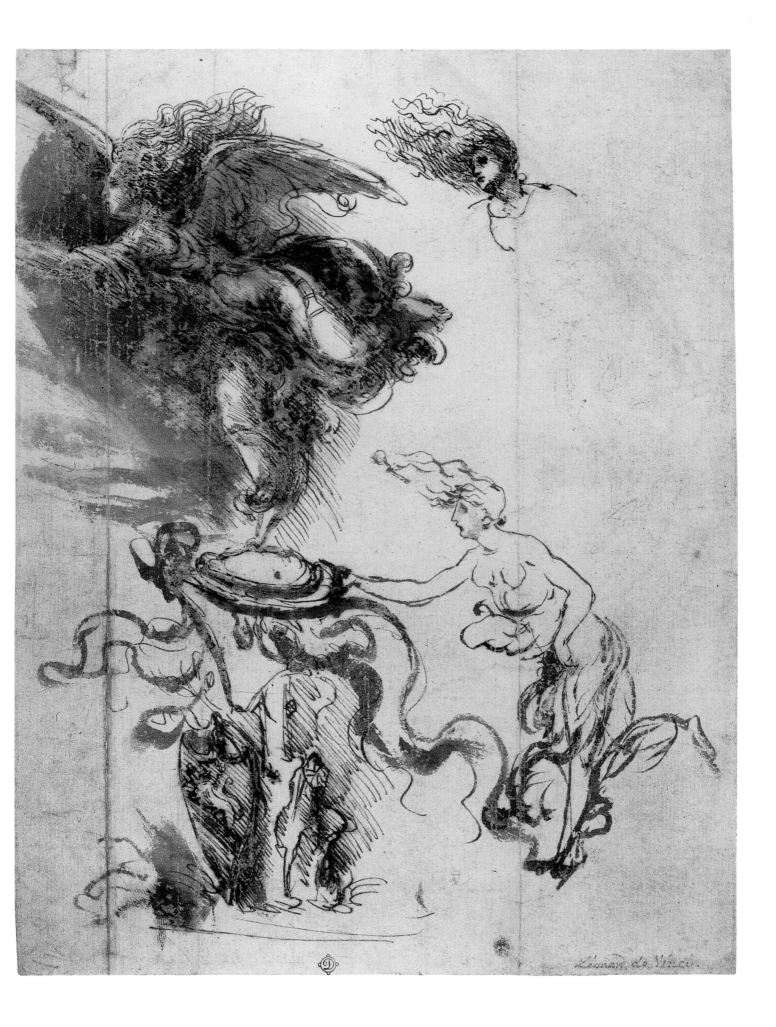

14

Saint Jerome

c.1485? Oil and tempera on walnut, 103 × 75 cm.
Musei Vaticani, Vatican City

The penitent Jerome in the desert is usually assigned to Leonardo's
first Florentine period; like the *Adoration* (Plate 9), it was left unfinished
with underdrawing visible. His teacher Verrocchio produced both two-
and three-dimensional images of Saint Jerome, characterized as highly
wizened and ascetic in dress if not also penitential in action. At the
monastery of Santissima Annunziata, where Leonardo resided when he
returned to Florence after the fall of Milan, Andrea del Castagno's fresco
of Saint Jerome flagellating himself with a rock, his chest bloodied from the
blows, still stands as one of the more gruesome images in fifteenth-century
Italian art. Even if Leonardo made this work soon after coming to Milan,
he remembered those Florentine prototypes. Totally new, however, is the
poignant expressivity of the face, which is fixated on a barely sketched
crucifix at the edge of the painting, just to the right of the building in the
background. This expression of troubled devotion has precedent only in
Leonardo's own *Adoration*. Castagno's Jerome, by contrast, is occupied with
a heavenly vision. Leonardo's kneeling figure looks desolately alone in his
consciousness of his sinfulness. The somewhat unusual ferociousness of
the open-mouthed lion, Jerome's attribute, is matched by Castagno's fresco.

The architectural sketch in the right background, appropriate to Jerome's
role as a Father of the Church, may indicate a later date, perhaps after the
artist had moved to Milan. The rocky setting as a natural framework for
the figure suggests comparison with the *Virgin of the Rocks* (Plate 15). The
inventory in 1525 of Leonardo's assistant, Salai, includes a *Saint Jerome*,
whose valuation might imply its being an unfinished painting.

The story goes that the panel was found in two parts in Rome by the
uncle of Napoleon, Cardinal Fesch, an avid art collector: one part in an
antique shop and the other in the shop of a shoemaker.

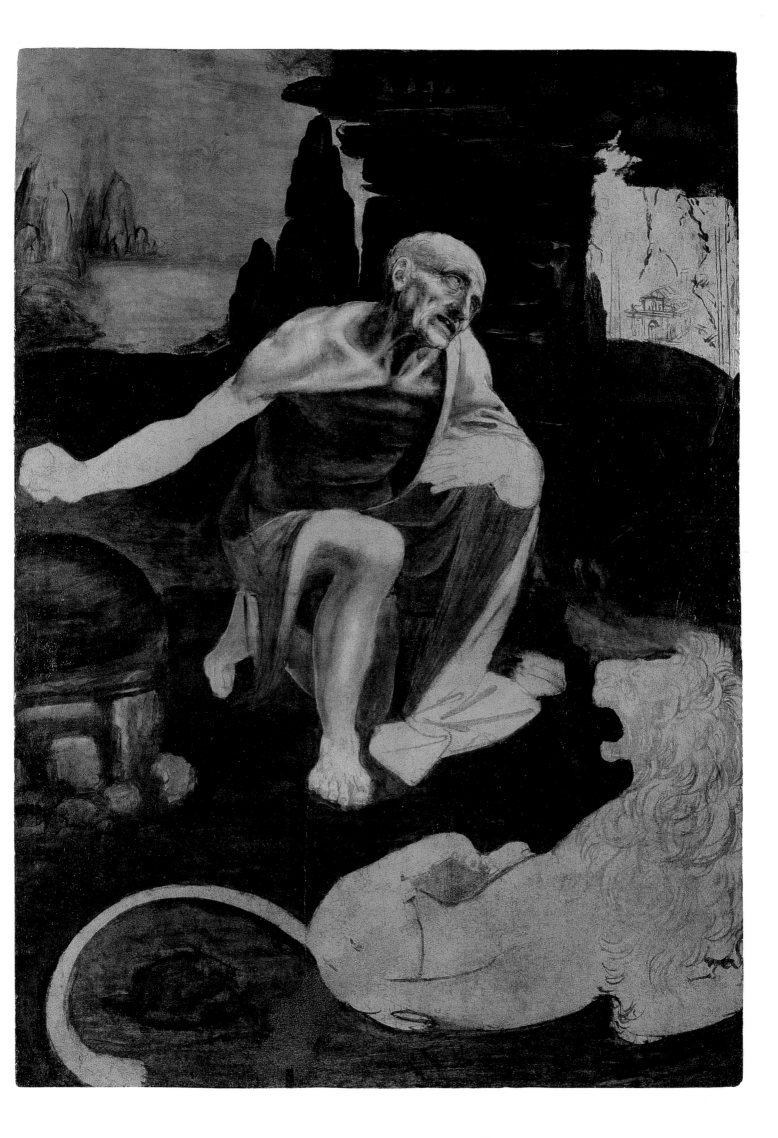

15 The Virgin of the Rocks (Virgin and Child with the Infant Saint John and an Angel)

*c.*1483–4. Oil on wood, transferred to canvas in 1841, 199 × 122 cm. Musée du Louvre, Paris

Fig.21
After Leonardo
Madonna of the Yarnwinder
*c.*1501–7 (?). Oil on wood (poplar?),
48.3 × 36.9 cm. Collection
of the Duke of Buccleuch &
Queensbury, Drumlanrig Castle,
Scotland

As was often the case in the fifteenth century, the original frame (since lost) for this painting was made first and the painting ordered afterwards. Three panels were to be made by Leonardo together with the Ambrogio and Evangelista de Predis brothers. The altarpiece was to go in the Chapel of the Confraternity of the Immaculate Conception in San Francesco Grande in Milan, together with some wooden sculptures as part of the same ensemble. The artist was accused of delays; the patrons were in their turn charged with undervaluing the work; and the upshot was that negotiations were still going on when Leonardo returned to Milan in 1506. We know that, for whatever reason, at a late date an assistant applied for permission to make a copy of the altarpiece. Two versions have come down to us, and more than one copy. The Paris version (seen here) is agreed to be earlier in style; there is considerable debate about how much of the version now in the National Gallery, London (Plate 40) is by Leonardo's own hand. In 1508 the Confraternity received a second version, which stayed in the church until the Confraternity was dissolved in 1781.

The Paris version may never have been delivered, because in the early 1490s Leonardo complained to his patron, Duke Ludovico, about the price he was offered and claimed that another buyer would give him 100 ducats, much more than the Confraternity. Like Caravaggio after him, it seems that Leonardo found himself in the position of having traditional patrons unsettled by work that private collectors were eager to acquire. The second version, the one that stayed in the church for centuries, had haloes; the kneeling Saint John the Baptist has his customary attribute of the cross resting on his shoulder, as well as a scroll inscribed in Latin 'Behold the Lamb of God' (John I:29).

The hovering hand of the Virgin recurs in the *Madonna of the Yarnwinder* (Fig. 21), a composition recorded in 1501 and known now only in copies.

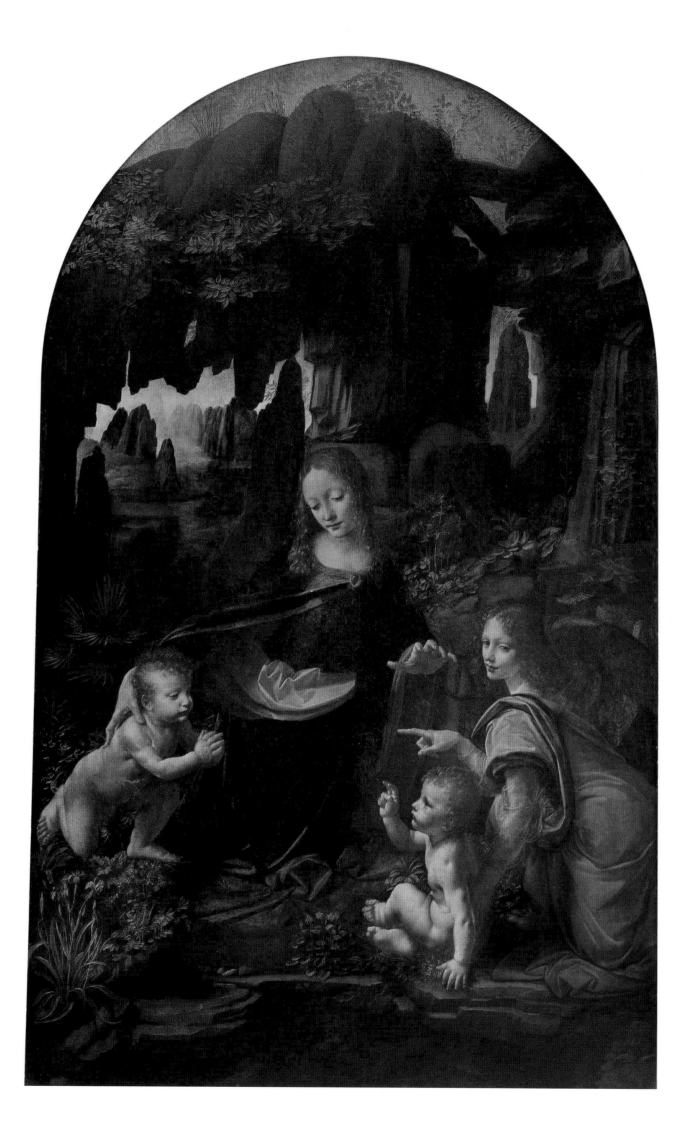

The Virgin of the Rocks (Detail)

Musée du Louvre, Paris

16

Preliminary sketches for this altarpiece suggest that Leonardo may have been prompted by a northern Nativity painting in which the Christ Child lay on the ground, adored by the Madonna; perhaps he heard about the arrival of the *Portinari Altarpiece* in Florence, which caused a stir there after he had left. His Madonna is both modest and protective; the Christ unexpectedly separated from her, but as a robust, blessing infant rather than as a weak newborn laid on a bed of straw. He is positioned closest to the worshipper, and an angel attends him, rather than the Virgin.

Just as Leonardo was confident enough to put Judas on the same side of the table as the others, here he resolutely places the small Child off centre and sideways, and furthermore shows the Virgin embracing the child who is not Christ. The composition is both daring and also highly calculated. Unusually for an altarpiece, the viewer's eyes are kept in constant motion by the complex arrangement of rocky ledges punctuated with foliage and by the magnetic pull among the unexpectedly distributed figures, each having a telling gesture.

Water and rock establish a setting that is at once natural and as strange and awe-inspiring as the cavern Leonardo reported visiting. He wrote in his notebooks that he had felt both fear and desire, fear of what the dark cavern might hold and desire to know. Rocks he elsewhere compared to bones, and rivers to blood.

Two accompanying panels survive at the National Gallery in London, each with a musical angel, presumably by the de Predis brothers for this altarpiece.

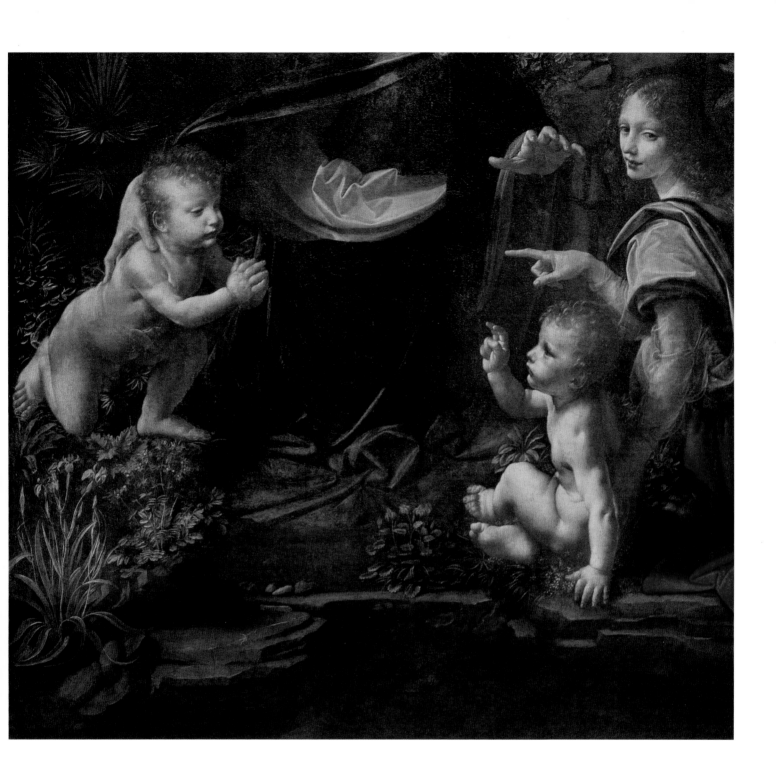

Study for the Sforza Monument

*c.*1485–90. Metalpoint on blue prepared paper, 15.2 × 18.8 cm.
Royal Collection, Windsor

Every line in this drawing vibrates with movement. Even the taut reins won't hold still. The customary hatch marks have in some places turned to zigzags because they were made with such energy, despite having been done in the normally cautious medium of metalpoint. Leonardo almost singlehandedly turned the world of pictures from static entities to ones bristling with movement, from frozen objects to flowing ones, from conveying a sense of eternity to portraying time itself. He was obsessed with the inevitable flow of time, that 'great destroyer', as he called it.

The parallel diagonal hatching had been previously used in very still images, studies in which the goal was to achieve convincing three-dimensionality, but here Leonardo effectively uses the discrepancy in alignment between the hatching in the neck of the horse and in the background, and also between two sections of the background, to aid the impression of movement. He evidently considered having the rider's right arm either thrust forwards or pulled back.

For nearly three decades Leonardo planned an equestrian monument that was never built: first in honour of Francesco Sforza, a mercenary soldier who rose to be Duke of Milan (1450–66), and later as a funerary monument for a mercenary soldier by the name of Gian Giacomo Trivulzio (d.1518), a native Milanese who ruled the city on behalf of the French invaders. To show a rearing horse rising over a struggling but defeated foe was a formidably ambitious project. In the end, just as Michelangelo eventually rescued some of his sculptural ideas for the tomb of Pope Julius II and adapted them to the Sistine ceiling project, so with Leonardo, whose *Battle of Anghiari* mural (see Fig. 34) benefitted from the years of thought dedicated to this doomed project. For a brief while, together with Michelangelo's unrealised *Battle of Cascina*, Leonardo's *Anghiari* became, as Benvenuto Cellini called it, the 'school of the world'.

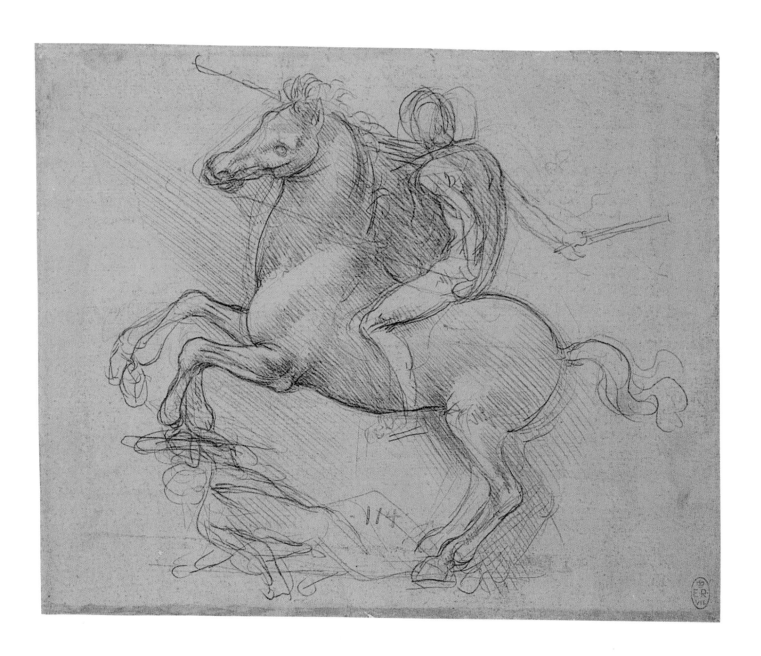

View and Plan of a Square Church with a Central Dome and Four Cupolas

1488–90. Pen and ink, 23 × 16 cm.
Bibliothèque nationale de France, Paris

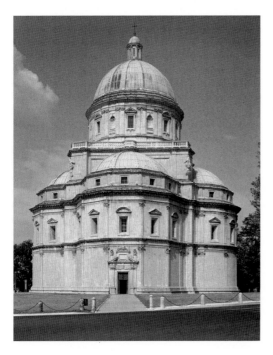

Fig. 22
Cola da Caprarola
(1508–1604)
San Maria della
Consolazione, 1508
Todi, Umbria

Leonardo never saw any of his designs for buildings come to fruition. He read Vitruvius and Alberti on architecture; he continually drew buildings, especially after he arrived in Milan; and he had estimable architect colleagues, Bramante and Francesco di Giorgio in particular. Milan Cathedral was begun in 1386; a century later, Leonardo and his colleagues were discussing how to build the octagonal central crossing tower, the Tiburio. Leonardo worked on a wooden model that has not come down to us. It is thought that near the end of his life he was propagating ideas about the new classical style in architecture that effected the design of the great châteaux of the Loire, Chambord in particular.

Leonardo was extremely persuasive, and Vasari tells us that he almost convinced the people of Florence to raise the Baptistery in order to insert a staircase beneath it. He even applied to the Sultan in Istanbul for the job of building a bridge over the Bosporus.

Renaissance architecture was founded on the basic classical idea of the analogy between the symmetry and proportionality of the human form and that of buildings. Leonardo's ideas for centrally planned churches expressed the same belief in the beauty of the circle and square as we find in the illustration of the 'Vitruvian Man' (Fig. 9). He started out thinking of a cubic building supporting a dome, later developing ideas in which the plan would be circular as well.

This church (Fig. 22), in an idyllic setting near the Umbrian town of Todi, is documented as the work of Cola da Caprarola, begun in 1508 and finished a century later. It is usually thought of as borrowing Bramante's ideas for the new St Peter's, begun in 1506, but both Bramante and Cola owed more than a little to the imagination and jottings of Leonardo. He wanted buildings to have a sculptural presence, to be experienced in the round as eminently intelligible forms.

What he has not yet mastered in this drawing, though he did in others (see, for example, his drawing of James the Elder, Plate 27), is how to avoid the octagonal drum, such as Brunelleschi used on the Florentine cathedral. Cola da Caprarola and Bramante both achieved the circular drum.

The ready relationship between words and images that Leonardo displays on this page, as on many others, is utterly characteristic of how he, and only he, worked.

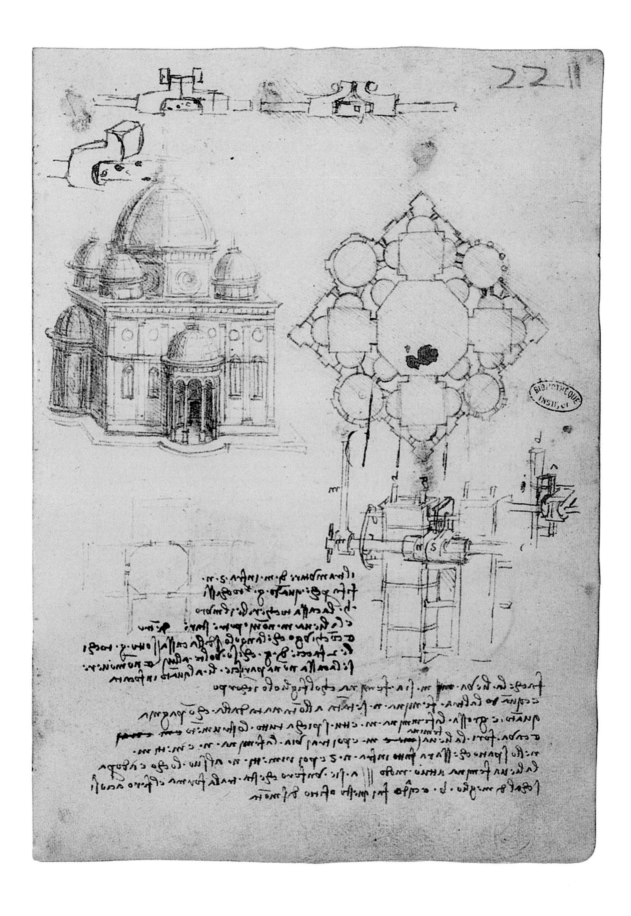

19

Portrait of Cecilia Gallerani
(Lady with an Ermine)

1489–90. Oil on walnut (inscription added much later), 54.8 × 40.3 cm.
Muzeum Narodowe, Kraków

Fig. 23
After Leonardo
Bust of a Young Woman with
a Garland of Ivy
1490–1510. Engraving lettered
round the edge of the circle
'ACHA LE VI' (Academia
Leonardo da Vinci), 13.6 × 13 cm.
British Museum, London

Cecilia Gallerani, a non-noble woman who had been engaged in 1483 at the age of ten to someone of similar station, was by 1487 trying to extract herself from that arrangement, the full dowry for which had never been paid. By then or soon afterwards, she was the mistress of Ludovico Sforza, then regent and later Duke of Milan. He was evidently devoted enough to Cecilia that he put off his impending marriage to Beatrice d'Este of Ferrara, sister of Isabella d'Este, Marchese of Mantua. That finally took place in January of 1491. Cecilia gave birth to Ludovico's son, Cesare, in May; and in July of 1492 she was married to Count Bergamini, both herself and her son being well provided for by Ludovico. She was known as a gracious and articulate hostess, someone who liked the company of learned men and to whom interesting people were attracted. Matteo Bandello, a contemporary writer of short stories, who described Leonardo's slow and thoughtful work on the *Last Supper*, compared her poetry, which has not come down to us, with Sappho's. Cecilia, the Countess Bergamina, died in 1536. She is usually judged to be 16 or 17 when she sat for Leonardo.

The portrait soon elicited a poem that praised Cecilia's beauty and, no less, Leonardo's mind and hand, and urged her to thank Ludovico for preserving her beauty for posterity. It is also mentioned in letters of 1498, when the painting was borrowed from Cecilia by Isabella d'Este to compare with portraits by Giovanni Bellini, brother-in-law of Mantegna.

Of all of Leonardo's surviving portraits, this has the most active composition. The poem describes her attitude as one of listening; both she and the animal she holds seem intent on something we cannot see. The animal, an ermine, is one that Leonardo refers to several times in his notebooks. It had emblematic value, as a creature that shunned dirtying itself. Ludovico belonged to the Order of the Ermine, and one of Leonardo's drawings may, due to its circular shape, have been intended for a portrait medal verso. It depicts an ermine submitting to capture rather than sullying itself.

Conveniently, the Greek word for ermine sounds like the beginning of Cecilia's surname. It was part of Leonardo's genius in this portrait to include a wild animal that never could have been held as it is shown here. Cecelia's elegant hand is given prominence as she seems in the act of stroking the animal. The twist of her body as she gazes over her left shoulder is accentuated by the unusually long pictorial field. She inclines in the direction she looks; the right margin of the picture plane is left blank. The original background was bluish-grey and lighter on the right. The sweep of hair under the chin is believed to be original, but to have lost some of its delicacy due to repainting.

The Academy associated with Leonardo, on the basis of this engraving (Fig. 23) and the similar inscriptions on the Knot engravings, was presumably some fairly informal coterie not unlike the intellectual circle Cecilia gathered around her, especially after her marriage.

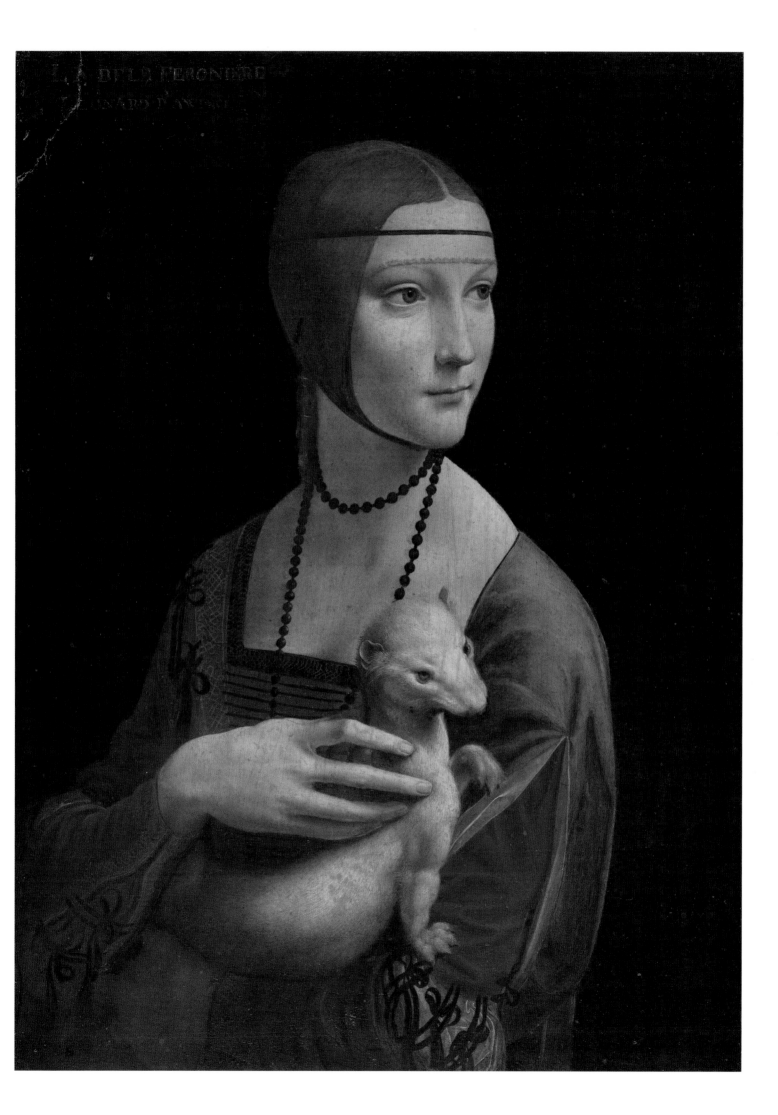

Anatomical Study of the Human Skull in Side View, showing the Eye Sockets and Maxillary Sinus

1489. Pen and brown ink over black pencil, 18.8 × 13.4 cm.
Royal Collection, Windsor

Leonardo combined observation of what was not easily measured – light and shadow in particular – with careful measurement when possible. Here he is plotting, both in two dimensions and three, the size and shape of a cranium, trying to locate, deep within the skull, the *senso comune* (the Aristotelian term for the locus of a sub-rational level of cognition, where sensory information was evaluated). This is a working drawing, although working towards anatomical knowledge rather than art.

Whereas Raphael's career is notable for the unprecedented degree of stylistic evolution he achieved, and Michelangelo's for stylistic consistency from beginning to end, Leonardo managed to combine steady stylistic objectives with transformative technical changes. The meticulous parallel diagonal hatching he achieved with the pen here was soon to become largely obsolete, replaced by chalk or, alternatively, by more impetuous pen work; his probings of the potential of oil, although sometimes disastrous, also yielded results far more atmospheric, highlights more evanescent, than any previous users of the oil medium had even attempted. Pen remained his preferred medium for drawings of the internal organs of the body, though not always done with such a delicate touch as here. Some parallel background shading can be found even in the late anatomical drawings.

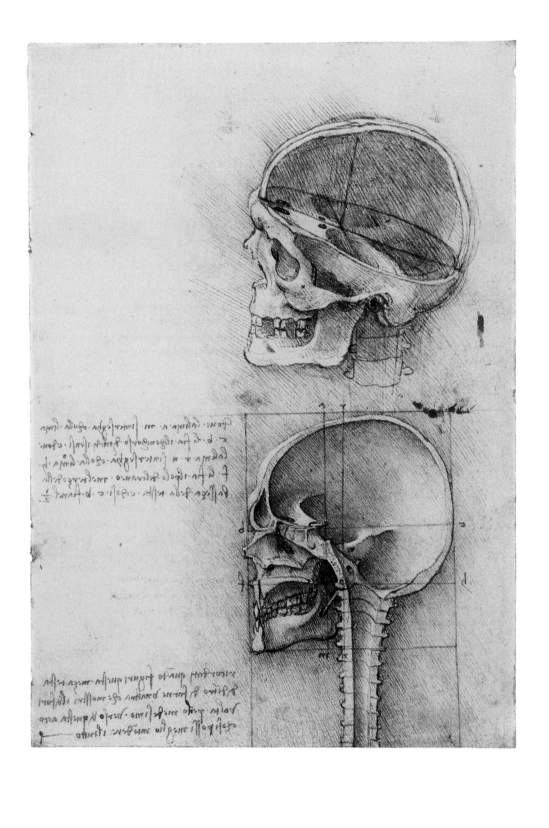

Studies of Hands and Arms

*c.*1490. Metalpoint with white heightening over charcoal on prepared buff paper, 21.5 × 15 cm. Royal Collection, Windsor

A better display of Leonardo's seemingly opposite abilities – to delineate delicately and precisely on the one hand, and to grope freely and sketchily, on the other – would be hard to find. On the right side of the sheet, the top of the arm disappears into a cloud of approximate lines; the white heightening with brush floats amid both straight regular and irregular, curved metalpoint marks; as sleeve blends into hand the marks blend into the illusion of surfaces alternately lit and shadowed. The brushmarks of the highlights display the textures of a close weave; the dense metalpoint marks describe the middle tones and blend with the darks reinforced with charcoal. There are other famous and beautiful drawings of hands in the history of Western art, but it is distinctive of Leonardo that he achieves so much effect in a drawing with passages of such different degrees of finish. Although a study only, rather than a finished work on paper (there is even a small caricature sketch in the upper left corner), the hands leap off the page.

Leonardo invented (with some help from his master Verrocchio) the idea of portraiture in which the face shares attention with the hands, and the dating of this drawing has fluctuated depending on with what portrait it is associated. It has no necessary relation with any surviving portrait, however, and has been done on a remarkably small scale. The continued though ever freer use of metalpoint and the inclusion of a caricature offer better clues to its date.

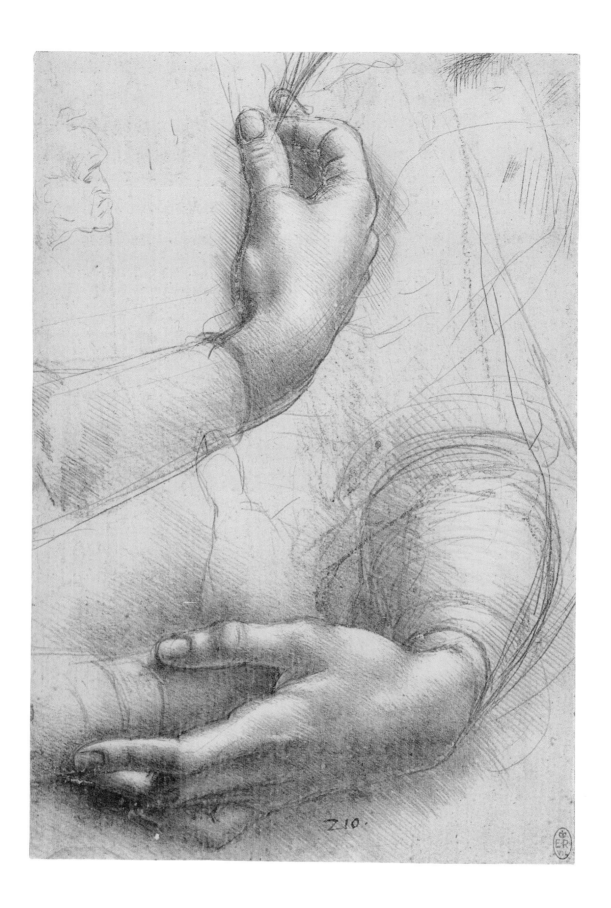

Z10.

c.1490. Pen and ink, 26 × 20.5 cm. Royal Collection, Windsor

Fig. 24
Wenceslaus Hollar
(1607–77)
'Divers Anticke Faces after
Leonardo da Vinci'
1666. Etching, 5.8 × 5.5 cm.
British Museum, London

The most prominent figure, shown in profile, wears an oak-leaf garland. His hood seems to have been added as an afterthought. He is embraced by a kerchiefed, nearly toothless woman to the left (a recent attempt has been made to identify this gesture as an attempt at pickpocketing). Between those two heads, chin up to expose the flaring nostrils and a large gaping mouth, a person of indeterminate age laughs. On the far right the figure with underbite is probably female; the frontal old man was likely the last to be added to the composition, since he seems to have been drawn over some of the background hatching.

Much hinges on whether the viewer takes the central figure to be old only, or subject to an element of caricature. If he with his oak-leaf crown and steady gaze signifies virtue in one way or another, then the framing figures in their ugliness might signify vice. Leonardo did have a taste for parable and allegory, a taste usually confined to his notebooks. A crown of oak leaves was awarded in ancient times for civic valour, in particular for saving the life of a citizen during battle, on ground that was subsequently held against the enemy. Recently an attempt has been made to identify the women on either side as gypsies, so as modern types. The hood on the central character's garment suggests a shift in identity from ancient to modern, since hoods were associated with monks and friars.

Whatever subject there may have been more or less distinct in the artist's mind, the drawing is very finished in parts, sketchy in others. The study of ugliness preoccupied Leonardo for years, as did the transformation of youth into age. Very few caricatures exude the vividness of the two women on either side, the one malevolent, the other very intent – though on what is not entirely clear. Like a dry run for the *Last Supper* (Plate 26), this drawing holds our attention because of the acuity of the minds portrayed. However, part of its fascination lies in the vagueness of any subject matter.

Wenceslaus Hollar (1607–77), originally from Prague, admired the drawing enough to etch it in reverse, on a slightly smaller scale, in 1666. He later extracted the gaping head at the back for the title page of a collection of etchings after grotesque drawings that he associated with Leonardo.

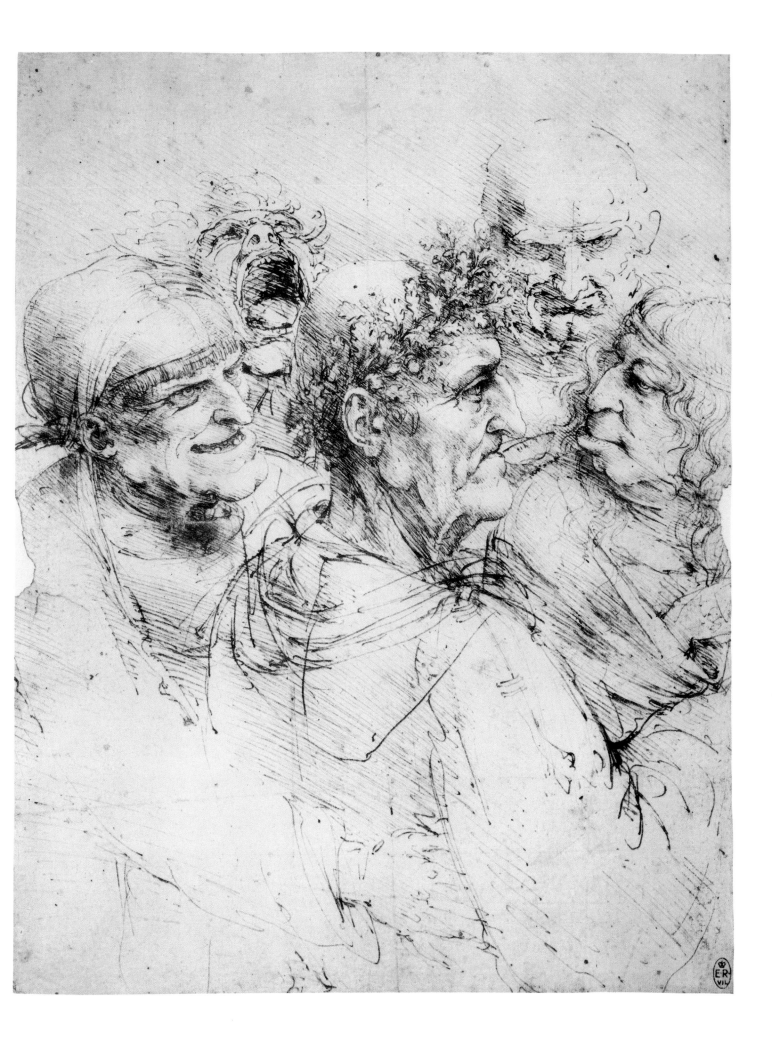

23 Study of Horse from Profile, Three-Quarters, and Frontal Views

*c.*1490. Metalpoint on blue prepared paper, 21.2 × 16 cm. Royal Collection, Windsor

Fig. 25
Studies of the Proportions
of a Horse's Leg
*c.*1485–90. Pen and ink,
25 × 18.7 cm.
Royal Collection, Windsor

Leonardo loved to draw horses. We know from his notes that he drew from life a Spanish jennet belonging to the Captain-General of the Milanese army and carefully measured the proportions of that animal. He also drew a breed called Sicilian. He expected the major accomplishment of his residence in Milan would be a bronze equestrian monument to Francesco Sforza (d.1466), an ally of the Medici, the father of the Regent Ludovico and a spectacularly successful mercenary soldier. This drawing is associated with that project. Even as the horse strides forwards, its hooves are close to or at the ground, as the stability of such a heavy sculpture would require. Leonardo also developed more ambitious poses for the horse, rearing over a fallen soldier, but at this point the only equestrian statues that had managed to free even one hoof from the ground were the ancient Roman statue of Marcus Aurelius in Rome and his own teacher's recently accomplished statue of Bartolommeo Colleoni in Venice (see Fig. 12). The riderless horses of San Marco, also in Venice, each have a raised hoof. Another statue from Roman times, since destroyed, the *Regisole* in Pavia, apparently had a raised but supported foreleg.

Metalpoint is not usually thought to lend itself to sketching, but Leonardo never obeyed that stricture. Here he combines the most meticulous of marks with very free ones. The blue prepared paper may have come from Venice, and we know that Leonardo visited nearby Pavia. He may not yet have visited Rome when he drew this sheet, though it is possible that he had seen either an engraving or a drawing of the Marcus Aurelius statue. The detail with which the skin and muscle is shown implies that, if not purely a study from life, some study from life would have been essential.

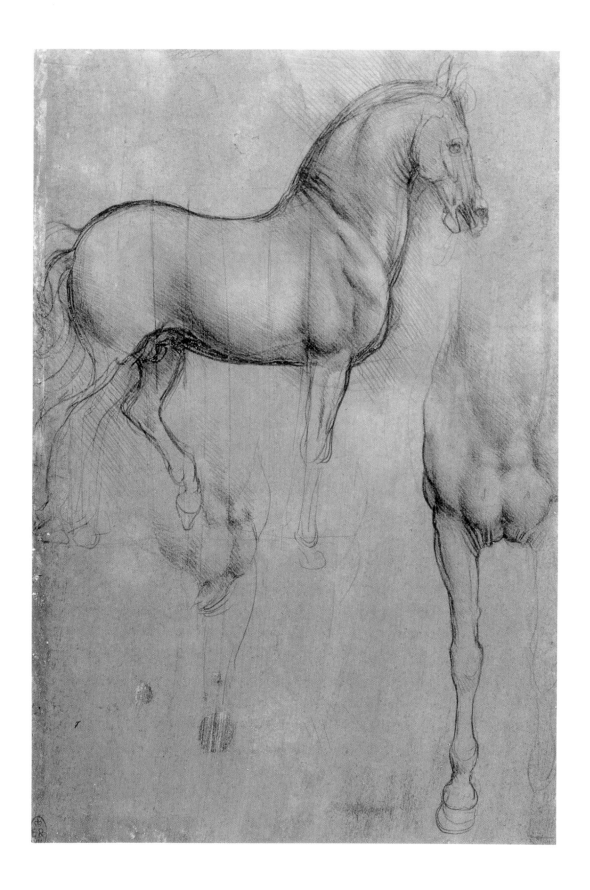

24 Allegory with Eagle and Mammal, Probably a Wolf

*c.*1495. Red chalk on brown-grey prepared paper, 17 × 28 cm.
Royal Collection, Windsor

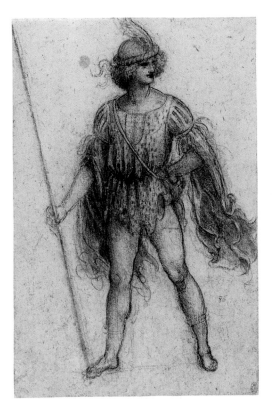

Fig. 26
Drawing of a Young Man in
Costume with a Lance in his
Right Hand
*c.*1517–18. Pen and ink over black
chalk, 27.3 × 18.3 cm.
Royal Collection, Windsor

Leonardo lived in Milan during turbulent times: in 1494 the French invaded Italy at Ludovico Sforza's suggestion, bound for Naples, and intending to chastise both the Pope and the King of Naples; the rightful duke died in 1495 under suspicious circumstances while Ludovico was regent; in the second invasion by the French in 1499, Ludovico was deposed.

This unusually finished drawing by Leonardo is plausibly supposed to represent favourably the French King Louis XII in the form of a powerful eagle perched on an orb, wearing a crown decorated with fleur-de-lys, opposing a wolf personifying Pope Alexander VI (Rodrigo Borgia), guiding a ship whose mast is a tree, perhaps the tree of life. Rays from the eagle's breast shine on to the compass, toward which the wolf gazes. If the ship symbolizes Christianity, its pilot rather than the ship itself is criticized; the wolf is probably intended to symbolize rapaciousness. This drawing was presumably commissioned to mark Ludovico's shifting political stance, away from allegiance to the pope and towards the French. If there ever were plans to make it into a print, the initial support for the French invasion soon dissipated and it seems the drawing remained in Leonardo's possession, to be left at his death to his assistant, Francesco Melzi. Leonardo's notebooks show that he had a taste for moralizing bestiaries and for fables, though whether he or a courtier came up with the idea here is impossible to say. Very likely it resulted from a conversation among various members of Ludovico's inner circle.

Leonardo's duties as court artist also included designs, costumes and novelties for festivities and plays at court. He provided balloon-like animals that would whiz through the air as they deflated. This jaunty fellow (Fig.26) may pertain to Leonardo's ongoing role as a designer of festivities, and is thought to date from his last years in France.

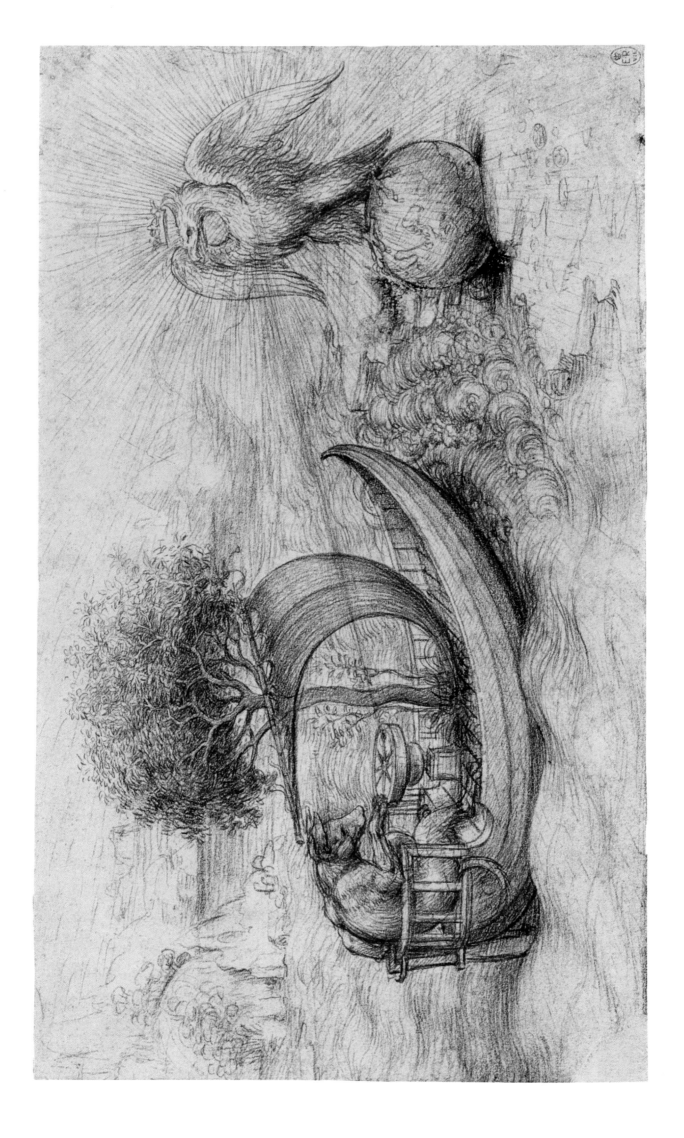

Portrait of an Unknown Woman ('La Belle Ferronière' *or* Portrait of Lucrezia Crivelli)

*c.*1497? Oil on walnut, 63 × 45 cm. Musée du Louvre, Paris

Poems were written in praise of Leonardo's portrait of Lucrezia Crivelli, a mistress of Ludovico Sforza, Duke of Milan. Lucrezia gave birth to Ludovico's son in March 1497, a few months after his wife died following a stillbirth. This could be that portrait. In some ways the painting is not particularly characteristic of Leonardo: the fussiness of the apparel and hair decoration, the restricted movement and the old-fashioned use of a parapet to separate real space and pictorial space. Still, she does stare out of the picture with an intensity no other portrait matches. The popular name *La Belle Ferronière* refers to the jewel on her forehead and the painting is referred to by this title in later French inventories.

Leonardo made notes to himself that there were eleven types of noses, viewed full face (ten in profile). He also made extensive notes to himself about the proportionality of the structure of the face. He combined that sort of analysis with defences of the importance of painting. A lover, he wrote, ought to find a painting of his beloved so compellingly real that he wants to speak to it. He boasted on behalf of the art of painting (which was commonly less esteemed than poetry), that if a poet and a painter each describe a woman, the lover will prefer the painting,

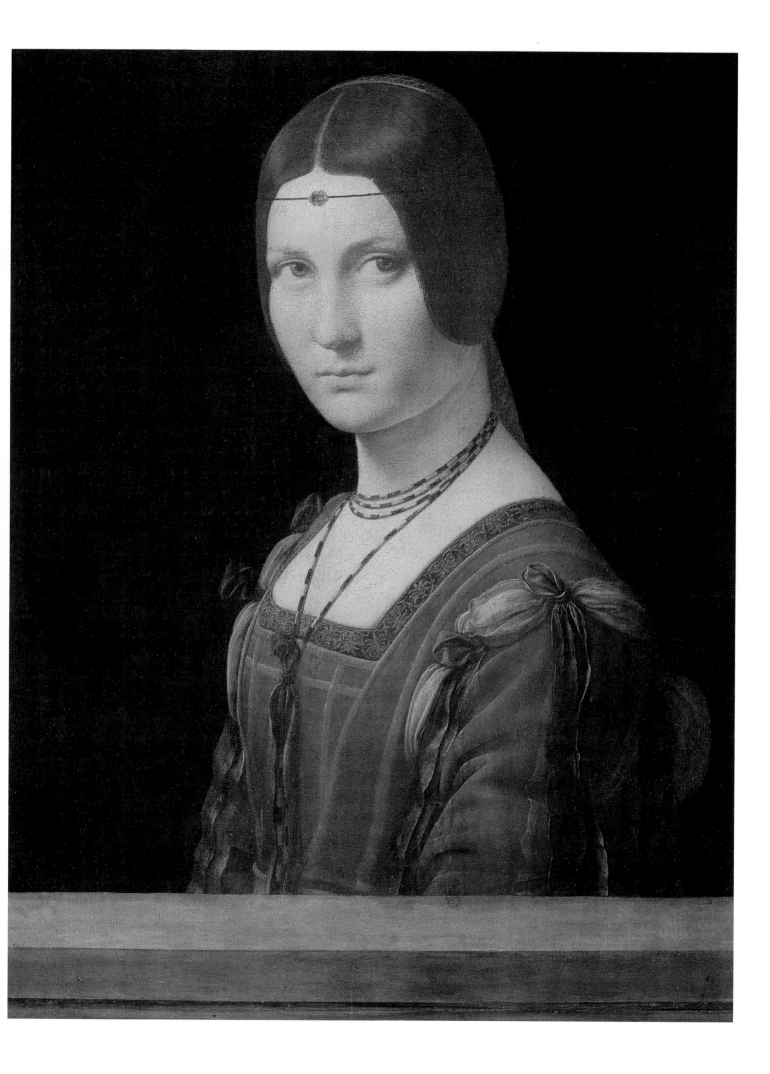

c.1494–7. Tempera and oil on plaster, 4.6 × 8.8 m. Santa Maria delle Grazie, Milan

Leonardo was working on his colossal equestrian project at the same time as the mural of the *Last Supper*. The writer Matteo Bandello describes how the artist would sometimes leave the sculpture, hasten to the Dominican refectory almost a mile away, make a few brushstrokes, and leave. It is characteristic of Leonardo that he would be thinking about the fierce soldier and the gentle Christ simultaneously. The *Last Supper* is a study in characterization: the perspective construction focuses in on the head of Christ, framed against the largest of three windows, the only one with a pediment, while the disciples almost all move in the opposite direction, appalled by the announcement that 'one of you shall betray me'. Judas moves differently from the others; he lunges backwards without *grazia*.

Ludovico, Duke of Milan, was the patron of the monastery, but the idea of painting the *Last Supper* may have been Leonardo's, since it was a common theme in Florentine refectories. He loved to watch how facial expression and gesture intimated the workings of the mind, and so this subject suited him perfectly. What had often been a dull scene of similar men seated behind a long table was transformed into a drama of simple action and complex reaction.

Leonardo's largest surviving work, the *Last Supper* is also the first work of art to become widely known through reproduction in various engravings made soon afterward (known as that with spaniel, Fig. 27, with cat, and even with rat) and in woodcut. Goethe visited it in 1788, and Napoleon in 1796. Henry James said of it in *Italian Hours* (1909), 'The picture needs not another scar or stain, now, to be the saddest work of art in the world; and battered, defaced, ruined as it is, it remains one of the greatest.'

Careful sandbagging and luck preserved the wall during the 1943 bombing that destroyed the surrounding structure, but Leonardo's attempts to improve on normal fresco technique, which demanded quick, decisive work and which normally produced a blonde tonality inimicable to his style, had resulted in a deteriorating condition and much restoration since the sixteenth century. Today the painting attracts over 300,000 visitors a year, even though tickets must be booked months in advance and viewers are allowed no more than fifteen minutes in the room.

Fig. 27
Giovanni Pietro da Birago
(active 1470–1513)
after Leonardo
The Last Supper,
with a Spaniel
c.1500. Engraving, 21.3 × 44 cm.
Metropolitan Museum of Art,
New York

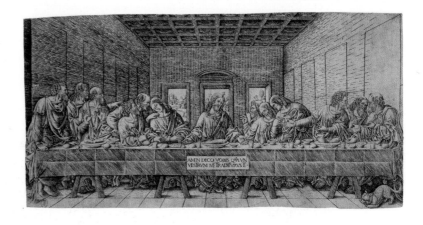

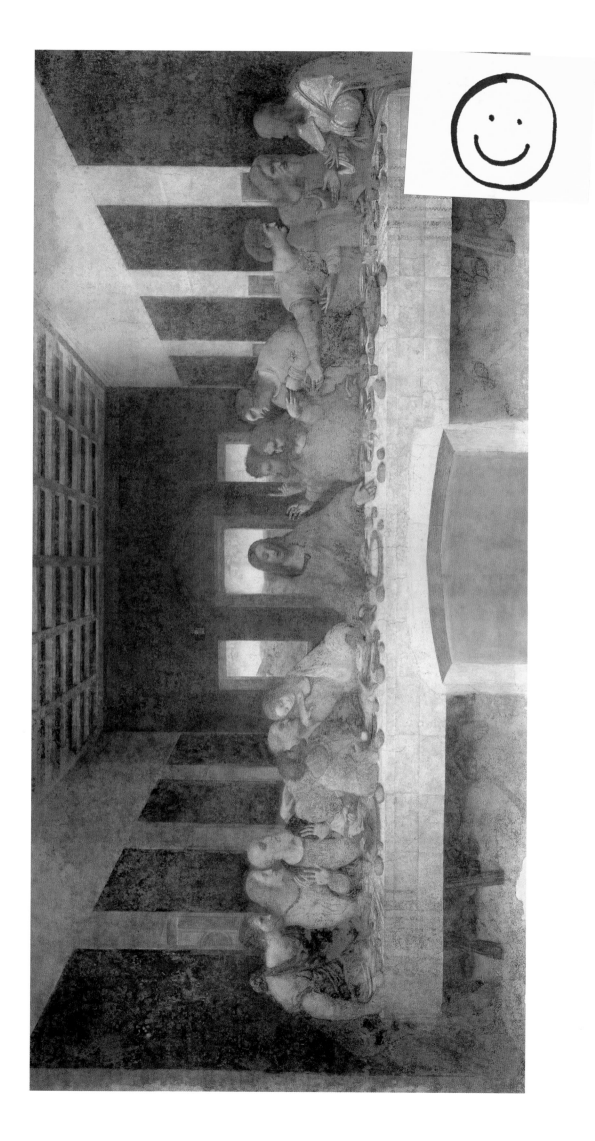

Study for the Last Supper (Saint James the Elder) and Architectural Sketches

*c.*1495. Red chalk, pen and ink, 25.2 × 17.2 cm. Royal Collection, Windsor

Fig. 28
After Leonardo
Head of Saint John the
Evangelist
1490s–1500s . Pencil, black
chalk, pastel and watercolour,
56.2 × 43.2 cm.
Musées de Strasbourg

To Christ's right, Judas, Peter and John the Evangelist form one of the four threesomes: the man who was so evil that no living model could be adequate; the most senior of the disciples, he to whom the gates of heaven had been entrusted; and the most beloved and junior. To balance them on Christ's left, Thomas, James the Elder and Philip are given particularly striking gestures.

In the fresco James is bearded, his hands wide apart. In the drawing, which has every appearance of capturing a startled moment from the life, Leonardo combines the parallel diagonal hatching associated with careful studies of three-dimensional form, often in metalpoint, with an impetuous shorthand for the hair. His touch on the paper ranges from light to hard; we can imagine that the first quick sketch was partially reworked, but that originally the entire sketch was in light, loose lines like those we still see for the hair. The open mouth and intense gaze he tried to preserve in the painted version, though the effect became more exaggerated for the purposes of the wall painting.

Paper had not been freely available to artists for more than a generation or so, and it was still precious, so it is not uncommon to see different ideas and/or different media juxtaposed on the same sheet. When Leonardo wrote about the skills he could offer at the court of Milan, after the long list of war machines came architecture, sculpture and painting, in that order. This pen sketch shows Leonardo already thinking about a more classical style for castles, such as would eventually be developed in the Loire châteaux after his death, and about a great domed space, even if attached to a traditional nave, as was the case with Bramante's church of Santa Maria delle Grazie. In the architectural drawings he has fundamentally rethought a corner turret, working through the sketches beneath and to the side, as part of a grand classical framework.

The Milanese artist Giovanni Paolo Lomazzo (1538–1600) tells us that Leonardo worked in pastel, although only later copies, such as this of Saint John (Fig. 28), have come down to us.

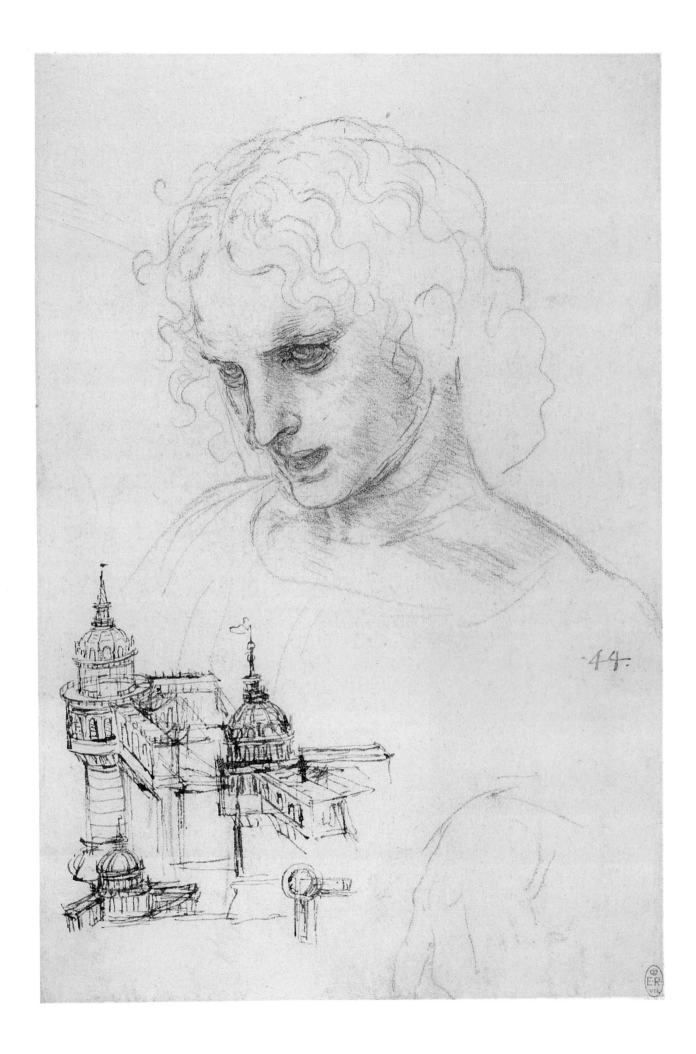

Sala delle Asse

*c.*1498. Tempera on plaster. Castello Sforzesco, Milan

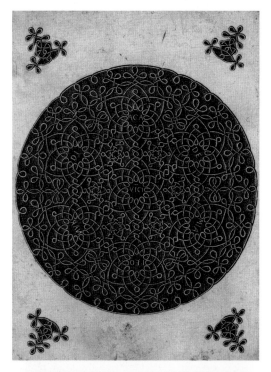

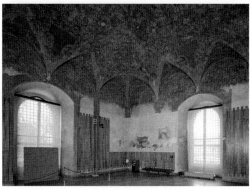

Among his most charming of schemes, although often overlooked now because of much repainting over the years, is Leonardo's transformation of a large squarish room in the Castello Sforzesco, home to Ludovico, Duke of Milan, into an arboreal bower. The effect is both very natural, as though one were in the midst of the woods, and very artificial, as the boughs of the trees interlace and, among them like an echo, appear ropes in elaborate knots – more complex versions of the knot engravings he designed and that Dürer admired sufficiently to copy in woodcut. Leonardo, when he saw the Sistine Chapel ceiling made more than a decade later in Rome, must have thought back to his Milanese project. In some ways much simpler – smaller in scale, non-figural, an environment rather than a compendium of stories – it was conceptually just as unprecedented. Tapestries had often shown scenes that took place in woods, but here the effect was of the natural vault of the trees. The decorative scheme implied that, in the vying of nature and art, art's superiority was not to be taken for granted – as Leonardo's contemporaries generally did. His was a mind that thrived on analogies rather than dichotomies or hierarchies.

The trees are probably mulberries, punning on Ludovico's nickname (*moro*), and the knots pun on Leonardo's name, the name of his hometown (Vinci – *vincolo*, that which fastens). At the centre of the ceiling, in a roundel seemingly open to the sky, floats a coat of arms for Ludovico and his wife Beatrice (d. 1497); four plaques commemorate important events of Sforza rule (one inscription has been lost). On one wall a tantalizingly unexpected fresco fragment showing rocks and roots has survived.

Fig. 29
Sixth Knot
1490–1500. Engraving with the words 'Academia Leonardi' broken up in six positions in the design, and the word 'Vici' in the centre. 29.3 × 20.7 cm.
British Museum, London

Fig. 30
Sala delle Asse, Castello Sforzesco, Milan

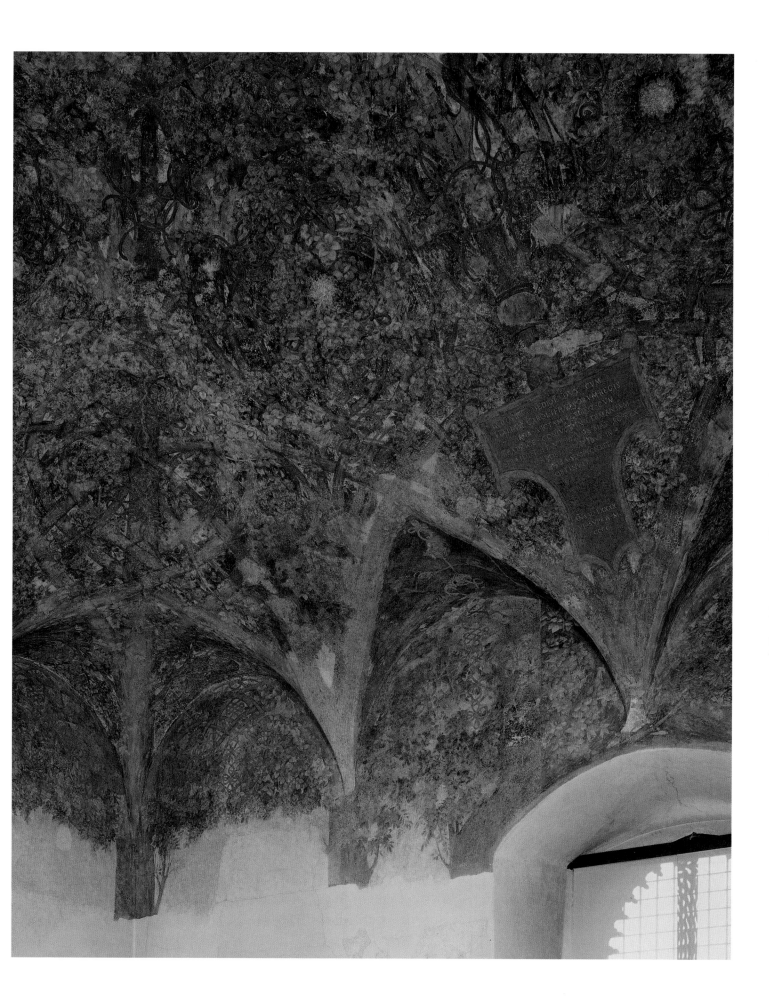

29 Study of a Rearing Horse

c.1503. Pen and ink and red chalk, 15.3 × 14.2 cm. Royal Collection, Windsor

88

Before Leonardo, knowing exactly where to place the contour was considered the mark of a good artist. Leonardo was so intent upon representing extremely vigorous movement, motions so quick that they could barely be seen, that he developed a new graphic language in which approximation counted as truer than specificity. Here the parts that are less in movement are worked up carefully in red chalk over some pen indications, the muscular surface rendered in places without any line evident at all. Underneath the belly of the horse is a second, pen sketch of a horse twisting in the opposite direction.

Leonardo admired horses and had a taste for scenes crammed with action. This rearing horse with hooves and head indicated in alternative positions is usually associated with the *Battle of Anghiari* (see Fig. 34) mural project for the Palazzo della Signoria, the town hall of Florence.

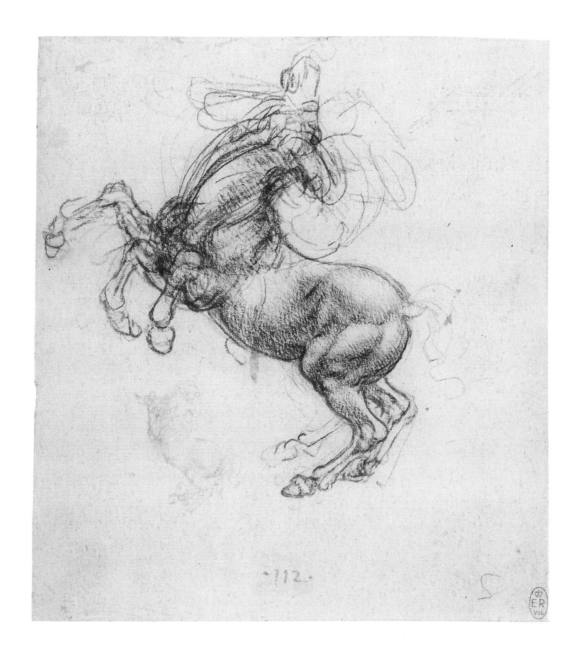

30

A Copse of Trees

*c.*1500–10. Red chalk, 19.1 × 15.3 cm. Royal Collection, Windsor

Leonardo used drawing to study nature rather than only as a preparation for painting. This small chalk drawing shows his prioritizing the effects of light and shade over the objective description of form. His predecessors had struggled to achieve the effect of three-dimensionality on a flat surface; Leonardo has put that project behind him and is striving to see the woods as a variegated space in which depth and darkness do not correspond in any simple way. This small, off-centre rectangle on the paper distils the artist's perception of myriad changing forms, shifting both in position and lighting. One could not attempt a subject more difficult to render on a small scale on paper. The boundaries of the image are as diffuse as the edges of the tree trunks and the leaves: nothing is crystal clear (he takes great advantage of the properties of chalk) and yet the essential woodliness of the scene – the impressive height of the spreading, shade-giving boughs and the irregularity of the tree trunks – is utterly convincing. Nobody before Leonardo had found woods so interesting and so complex a sight.

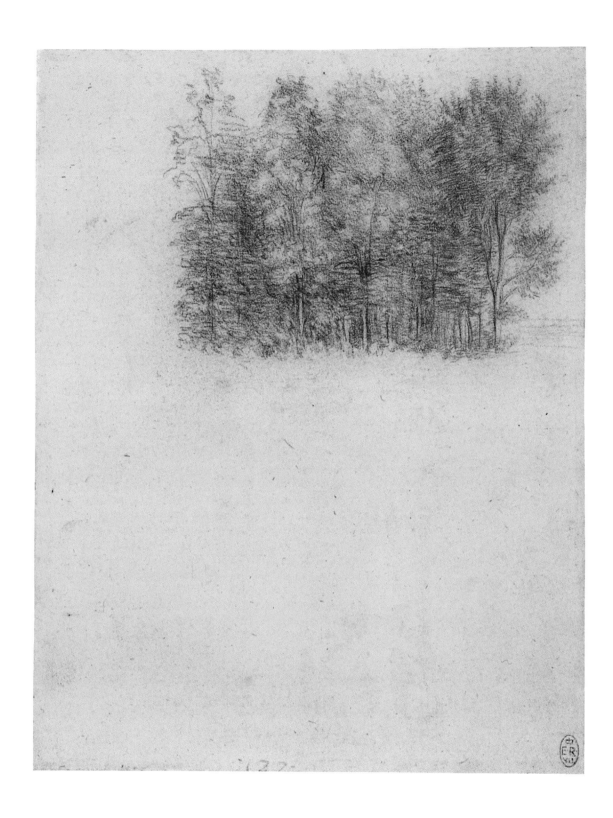

The Virgin and Child with Saint Anne and John the Baptist

c.1500. Black chalk and touches of white chalk on brownish paper, mounted on canvas, 141.5 × 104.6 cm. National Gallery, London

This assemblage of eight sheets of heavy paper is a miraculous survival, twice over. It is the earliest large-scale preparatory study (or 'cartoon', from the Italian word *cartone* meaning a large sheet of paper) to have survived – a monument to the respect drawing had in Renaissance Italy and its cultural descendants – and it was rescued, with astounding patience and precision, by conservators after a shotgun was blasted at it in 1987. It was purchased with the help of public subscription in 1962, for what then seemed the astounding price of £800,000.

Presumably Leonardo was trying out ideas that eventually resulted in the painting now in the Louvre of the *Madonna and Child, with Saint Anne and Lamb* (Plate 39), but without John the Baptist. Two sixteenth-century sources, Vasari and a letter written from Florence in 1501, describe a cartoon with a lamb and without John the Baptist, which Vasari says was later taken into France.

The London cartoon shows Saint Anne and the Virgin as a pair, the older woman gazing lovingly at the younger, and she in turn at her son, who blesses an attentive John the Baptist. His small figure, braced and leaning slighting into the picture space, closes off the flow created by the Christ's positioning. The unusual pose of the Christ Child has reflections both in Raphael's *Bridgewater Madonna* (National Gallery of Scotland, Edinburgh) and Michelangelo's *Taddei Tondo* (Royal Academy, London): it made the most important figure in such a composition into the most dynamic, thereby solving a longstanding problem of how to compensate for the relative smallness of the crucial figure.

As in the *Virgin of the Rocks* (Plates 15 and 40), Leonardo uses his powers of conveying expressivity, both through the face and hands, to loosen up the normal rules of composition. Saint Anne is at the centre of the composition. Her intense gaze from deep within the picture space out towards the Virgin is the pivot of the whole composition. In addition, her gesture to heaven reinforces Christ's blessing. Christ touches John's chin. The group of softly draped females and infants was to be set against rocky ledges, as was typical of Leonardo but unusual otherwise.

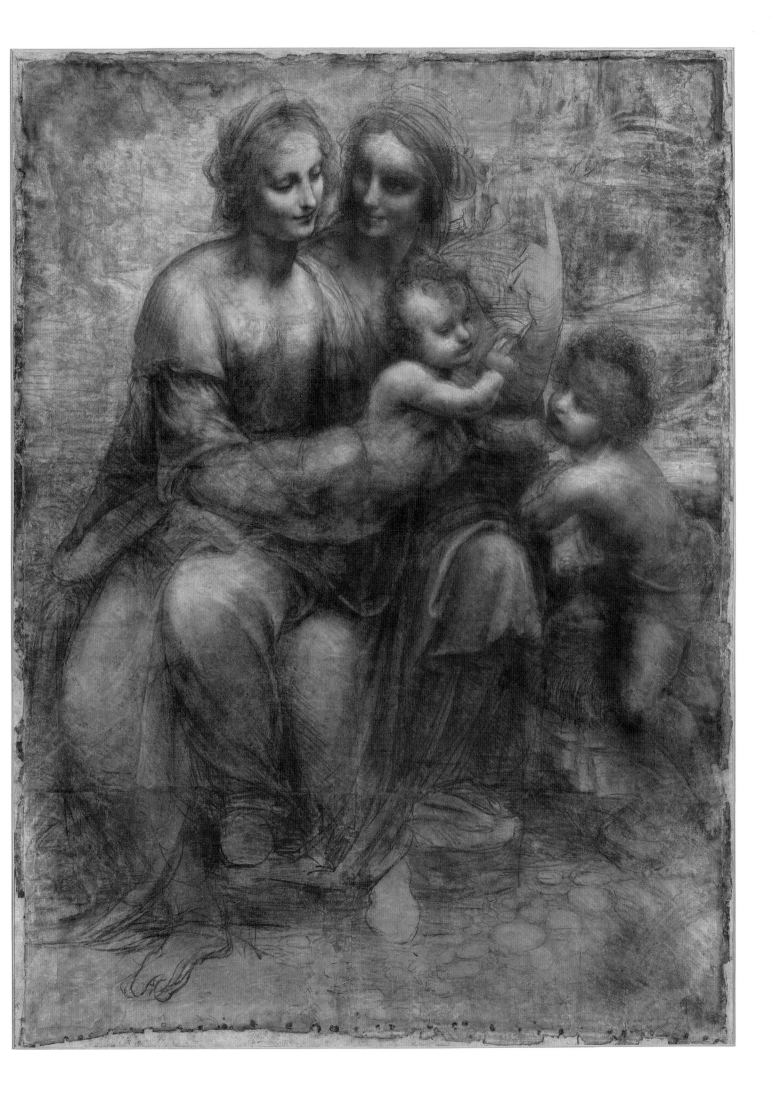

The Virgin and Child with Saint Anne and John the Baptist (Detail)

National Gallery, London

Leonardo never exceeded the beauty of shading he achieved here in these two women's matched yet differentiated faces. Most of his contemporaries associated beauty with bright lighting and clarity; Leonardo recommended in his notebooks the evening light as most flattering to the face. Anne was old when she became a mother, so it is with some poetic licence that Leonardo resists contrasting the two faces. Instead, the Virgin looks a bit older than she might, and Anne much younger. Both are bathed in the softening shadows of dusk. The Virgin is somewhat more brightly lit, but Anne is at the centre, so the eye cannot rest on either, but travels around the picture space. The mind, following Anne's finger pointing to heaven, travels even further.

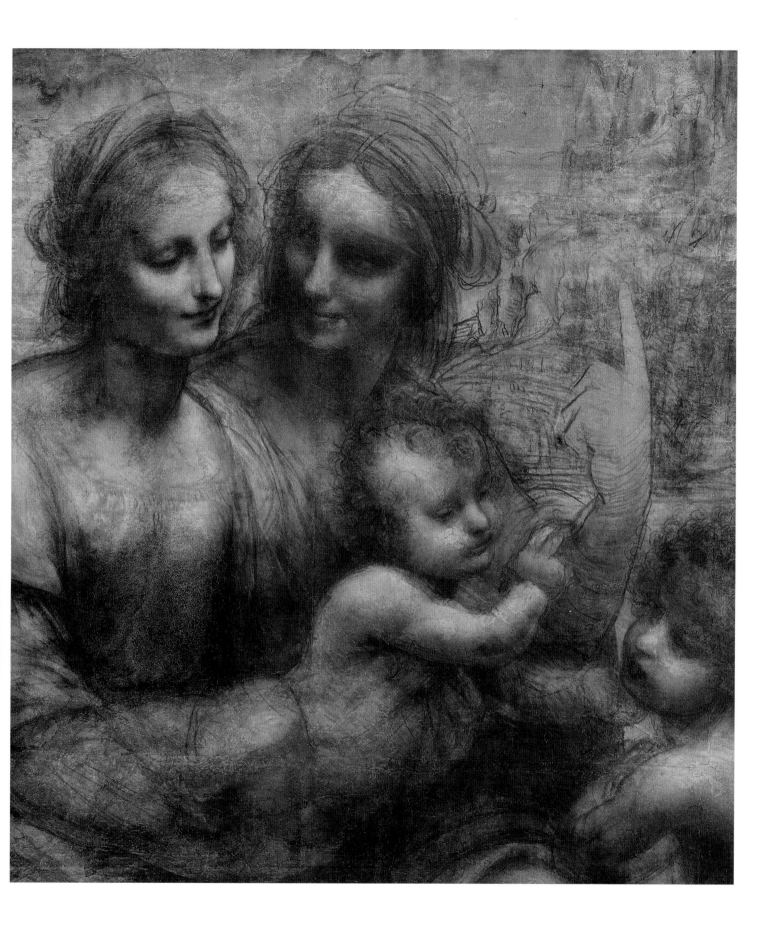

Portrait of Lisa Gherardini, Wife of Francesco del Giocondo (Mona Lisa *or* La Gioconda)

1503–6. Oil on poplar, 77 × 53 cm. Musée du Louvre, Paris

Vasari tells us that Leonardo painted the wife of Francesco del Giocondo, called Mona (short for Madonna) Lisa, and that this work was later owned by Francis I. It is highly unusual for a portrait not to be delivered to the sitter, which has led to speculation that either the work was deemed still unfinished or that it never was a commissioned portrait of a relatively undistinguished Florentine woman in her mid-twenties. It is quite a coincidence that this portrait, famous for its austere smile, would have been commissioned by a man whose name connotes cheeriness (*giocondo* means 'light-hearted' in Italian), though Leonardo was not above making a pun when circumstances seemed conducive, as the portrait of Cecilia Gallerani (Plate 19) shows.

Edges of Ionic columns are visible on the sides, a clue that the painting may have been cut down. Mona Lisa is seated on a loggia, against a landscape distinctly not of Florence, with a bridge on one side and a road on the other, but otherwise uninhabited. The landscape offers an abstract study of colour and texture, rather than any concrete sense of place. The mountains provide a jagged horizon that effectively, though not overly efficiently, directs the viewer to Mona Lisa's eyes. The edge of her transparent veil, scarcely visible and scarcely felt, produces the most insistent line in the whole composition, a very delicate line visible across her forehead.

It is unusual for a married woman, the mother of several children, to have her hair loose (albeit underneath a transparent veil); it may be that Leonardo insisted on this as a means of softening the lines of the neck. It is also possible that he chose to do this particular woman's portrait in order to have control over such matters as how the hair was worn, the colours of her clothing and the absence of jewellery. She would have been honoured to have had her portrait done by Leonardo – as would not have been the case with Lucrezia Crivelli, for instance – and she would have sat more patiently for the slow-working artist.

The painting was admired from the start. Raphael, among others, took it as a model. Vasari, who had never seen it, nevertheless praised it highly. He tells us that the woman's expression was induced by having her entertained by musicians while she sat for long hours. In the nineteenth century the painting's fame spread when Walter Pater wrote an elaborate prose poem in its honour: 'Hers is the head upon which "all the ends of the world are come" [I Corinthians 10:11], and the eyelids are a little weary.' In 1911 the painting made international headlines when it was stolen from the Louvre by an Italian (it was recovered in 1913) and acquired notoriety when Marcel Duchamp drew a parody of the image on a postcard in 1919 as one of his 'readymades'.

The portrait represents Leonardo at the height of his powers as a painter. The composition is both highly complex and subtly unified; the sitter appears both stately and full of incipient movement, not least in the eyes and mouth; she manages to seem both reserved and authoritative. The light, and equally so the shadow, seem utterly evanescent and transitory. The picture is full of mood and implication without being limited by particular actions or attributes.

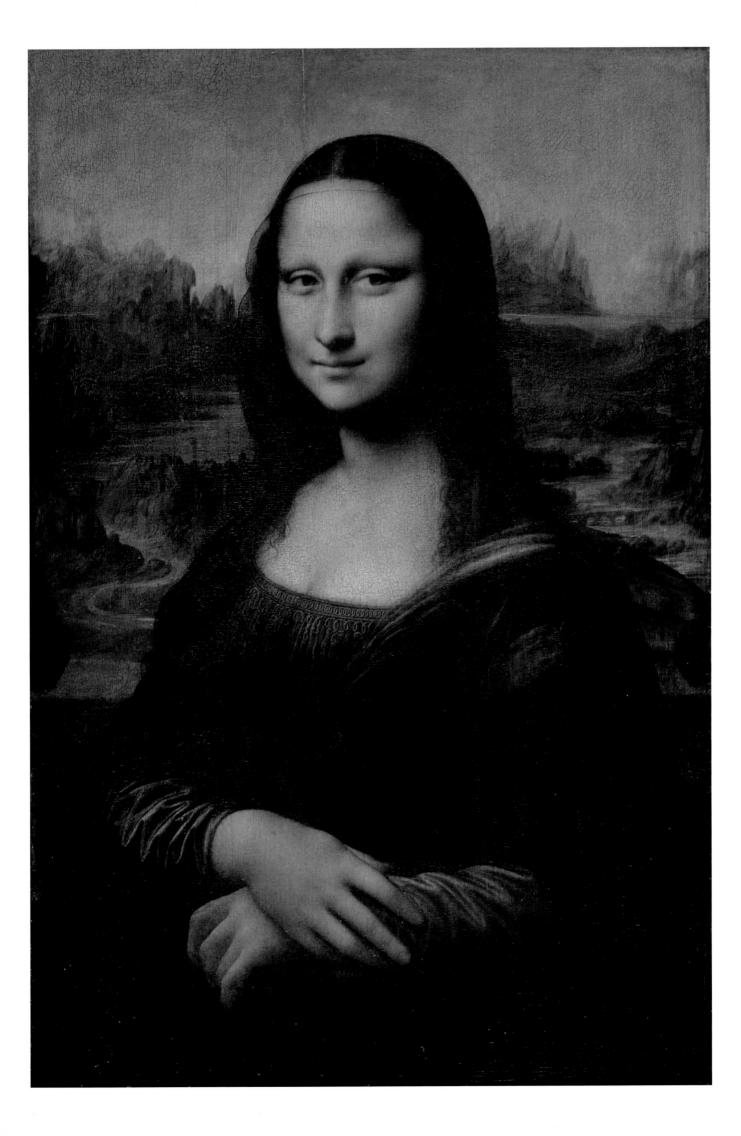

Portrait of Lisa Gherardini, Wife of Francesco del Giocondo (Detail)

Musée du Louvre, Paris

Leonardo had long experimented with the expressivity of hands, and the *Mona Lisa* succeeds partly because of the unexpectedly effective device of hands at rest, slightly off-axis. A similar pose of the hands can be seen in the cartoon for a painting of Isabella d'Este (Fig. 3), though there the hands and arms were used less successfully as a kind of substitute parapet.

In the *Mona Lisa* the space at the bottom was opened up, somewhat as in the base of the *Virgin of the Rocks* (Plates 15 and 40). The flesh of the hands glows; it is almost as though the sleeves glow from within, rather than merely receiving light. The sitter's darkly coloured clothes cover a range of textures, and fold with a variety of shape comparable to the vegetation in one of Leonardo's landscapes. The nails and the joints are barely delineated; the fingers of the hand underneath are surprisingly indistinct. Nevertheless, these hands express the sitter's meditative repose perfectly. The most iconic gesture in the art Leonardo knew was that of prayer; here Leonardo invents a secular equivalent.

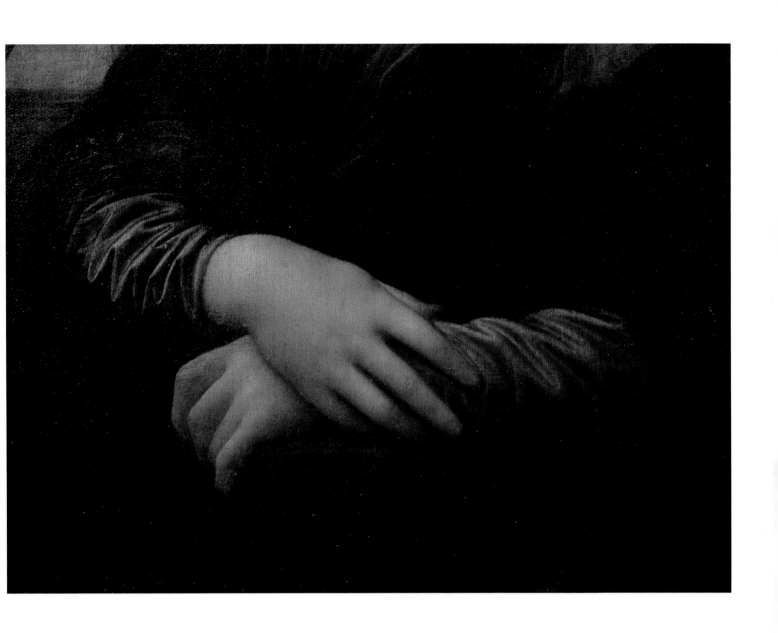

Study for Kneeling Leda

Begun *c*.1504. Pen and brown ink, brown wash over black chalk (inscribed 'leonardo da vinci' lower right by a later hand), 16 × 13.7 cm.
The Devonshire Collection, Chatsworth, Derbyshire

Fig. 31
Raphael (1483–1520)
Leda and the Swan
c.1506. Pen and ink over chalk,
31 × 19.2 cm.
Royal Collection, Windsor

In ancient myth, Leda was the mother of Helen and Clytemnestra, two wives crucial to events associated with the Trojan War, and the twins Castor and Pollux, who became famous as horsetamers. Leda had been seduced by Zeus in the form of a swan; hence the infants emerging from eggs on the left of the drawing.

Leonardo's drawings for this project show him trying out the idea of a kneeling, twisting figure as a pair to the swan with its curling neck. However, it seems that Leonardo painted, or at least planned to paint, a standing Leda, because several paintings of the subject in the style of Leonardo have come down to us. These copies suggest a painting of reasonably large-size, perhaps 130 centimetres in height. A drawing by Raphael from around 1506 (Fig. 31) shows a standing version of the scene that bears a close resemblance to the extant copies. It was from this compositional idea that Raphael would eventually develop his gloriously vibrant fresco of the *Triumph of Galatea* in the Villa Farnesina, Rome.

The subject would have been startlingly new, although Leonardo might have seen an ancient sculpture of a kneeling *Leda* in Rome. We do not know who might have commissioned the project, though it would seem more likely that it was a princely than a Florentine patron. Since we know of no painting commissions from Cesare Borgia, for whom Leonardo was working at around this time and who could be imagined to have such taste, he is a possibility – though only if the project predated Borgia's downfall in 1503. Louis XII has also been suggested as a possible patron. The subject was quite popular after Leonardo initiated it, both in prints and paintings, often showing the copulation rather than its outcome.

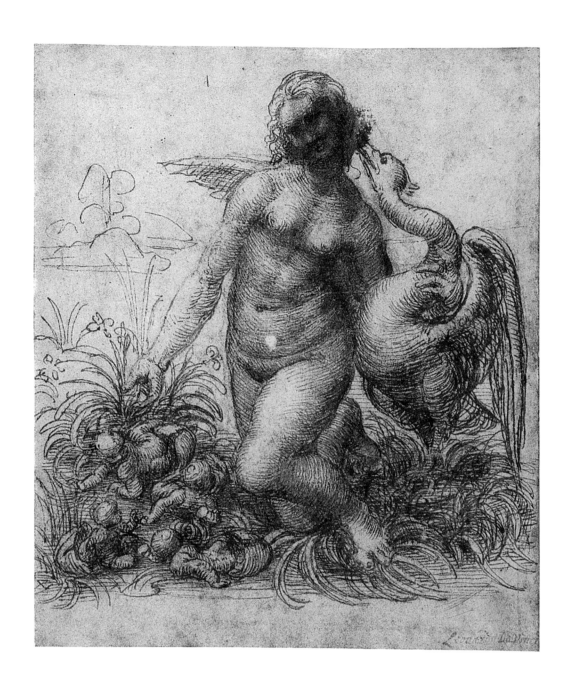

Studies of Women's Hair

c.1504–6. Pen and ink over black chalk, 20 × 16.2 cm. Royal Collection, Windsor

It was common Tuscan artistic practice to draw extensively, and Leonardo was no exception. He was fascinated with braids and knots (one imagines he must have relished the Romanesque carvings of knots on the portals of Milanese churches) and made many studies of the inclined head of Leda with elaborately interlaced braids.

The tilt of the head is usually thought to connect this set of drawings with the project for a painting of Leda (see Plate 35), though it would be relatively late for him still to be employing the parallel diagonal hatching. The designs of the hair are fantastically elaborate, including two studies of the back of the head, not visible in extant copies of the painting. The juxtaposition of the loose tendrils of stray hair with the hard tight braids, together with the modest downward gaze of the woman, had precedents in Leonardo's images of the Virgin (although Leda's is a less restrained coiffure than might have been deemed appropriate for the Virgin Mary) – and bears comparison with Michelangelo's later chalk drawings of women's heads. Like those, but more unusually in the case of Leonardo, this work was presumably done from imagination rather than from life. In the upper left, in black chalk, is a study purely of knots.

In his notebooks, Leonardo explicitly compared the patterns one sees on the surface of flowing water with those of braided hair, and his drawings in Fig. 32 show the sorts of forms he was noting.

Fig. 32
Studies of an Old Man and
of Swirling Water
c.1510. Pen and ink,
15.2 × 21.3 cm.
Royal Collection, Windsor

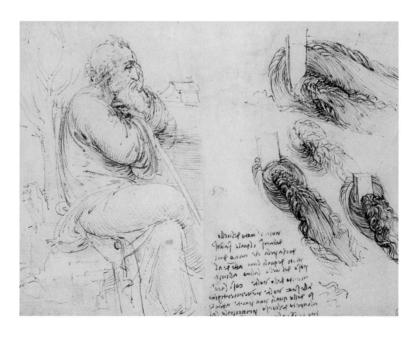

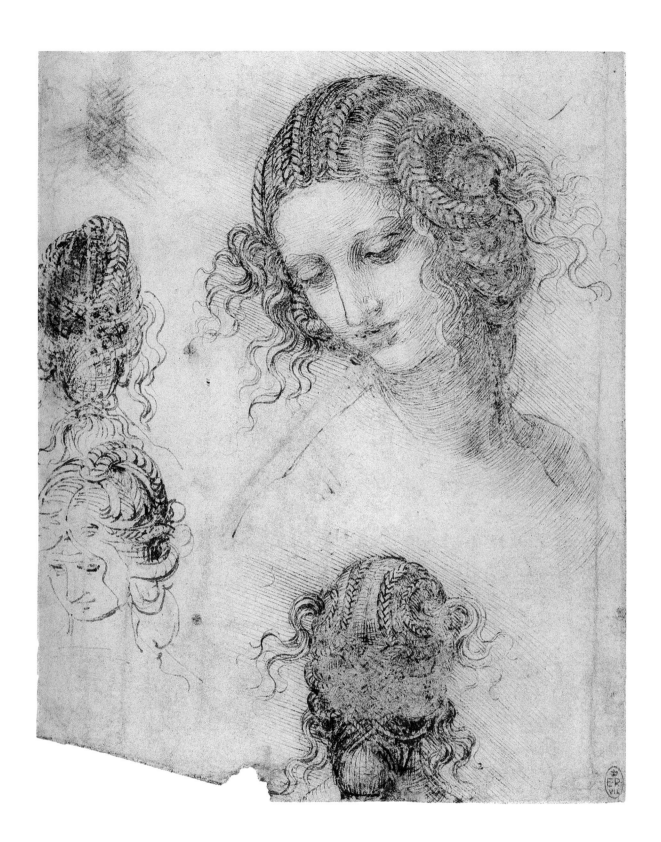

Star of Bethlehem (*Ornithogalum Umbrellatum*) and Other Plants

1505–8. Pen and ink over red chalk, 19.8 × 16 cm. Royal Collection, Windsor

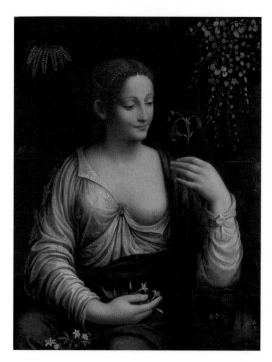

Fig. 33
Francesco Melzi
(1493–1570)
Flora
1520s, 76.5 × 63 cm.
The State Hermitage Museum,
St Petersburg

Leonardo's drawings of plants show him, as ever, studying nature meticulously, trying to understand the growth and reproduction of the organism, its structure and its capacity for movement. This drawing is usually referred to by the colloquial name of its largest plant, the Star of Bethlehem, though it includes several other plants the exact identification of which is disputed among botanists. It has been suggested that the plants all flower in late spring or early summer, and, alternatively, that all the plants on the page are toxic.

Leonardo's paintings include many carefully studied plants; this drawing is usually associated with the lost Leda, which was to be set on marshy ground (incidentally not appropriate for Star of Bethlehem). Leonardo studied plants for the sake of knowing about them, and then used that knowledge in his paintings. As he himself wrote, among a set of notes about plants: 'O Painter! ... it would be good for you to portray every thing from nature, and not despise such study as mere wage earners do.'

The extraordinary collection of drawings by and after Leonardo at Windsor Castle is thought to have been acquired by Charles II from Thomas Howard, Earl of Arundel (1585–1646), who had in turn bought them from Pompeo Leoni, a sculptor active in both Milan and Spain, who acquired what he could of Leonardo's papers kept by his assistant Francesco Melzi, which were dispersed at Melzi's death in around 1570. The painting attributed to Melzi of *Flora* indicates one of the pictorial traditions that developed out of Leonardo's preoccupations, but which, as far as we know, reflects no prototype by Leonardo.

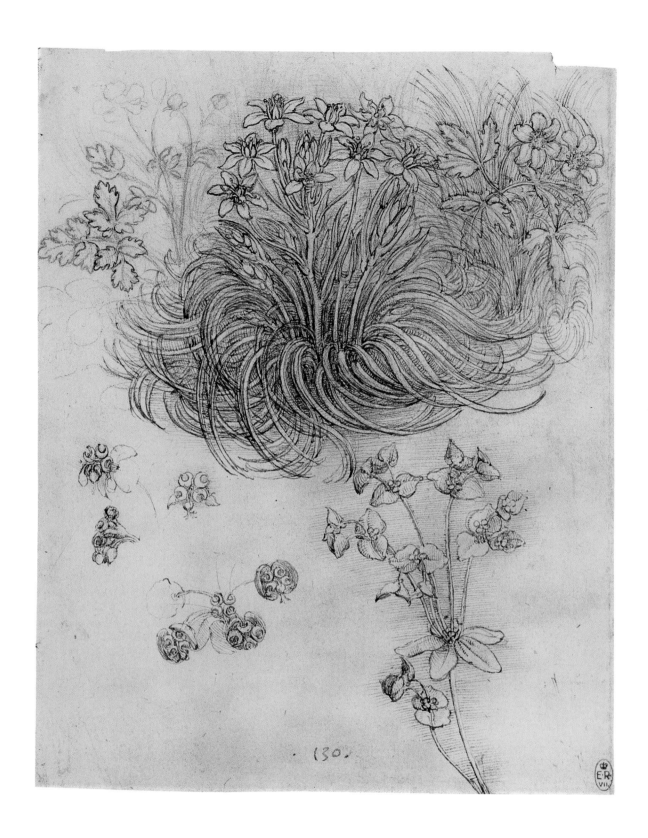

Study of the Heads of Two Soldiers

1503/4. Black and red chalk over metalpoint, 19.1 × 18.8 cm.
Szépművészeti Múzeum, Budapest

When Leonardo returned to Florence after the fall of Milan to the French, he came as a distinguished artist. The *Battle of Anghiari*, commissioned by his native city, ought to have been the crowning work of his career: a very large, complicated equestrian battle, ornamenting the council chamber of the town hall of Florence. Instead, we have only his admittedly incomparable preparatory drawings. His studies of heads for the *Battle of Anghiari* are among the first grimacing figures performing heroic deeds, accomplished just before the ancient *Laocoön* was dug up in Rome, and legitimized the idea of heroic suffering. When he wrote notes to himself about what a battle painting should look like, it was not glorious triumph he described, but blood-soaked earth, the trail of bodies dragged across dust and mud, the teeth visible in the mouths of those who scream in lamentation, and the clenched fists of the dying.

The battle had taken place twelve years before Leonardo was born. Niccolò Machiavelli in his *History of Florence* claims that only one man was killed in four hours of battle, and only because he fell from his horse and was trampled. He says, further, that the battle was important for the Florentines to avoid subjugation by Milan, but that the losers weren't much hurt by it. Machiavelli may have had a hand in choosing the subject given to Leonardo, but the historical facts didn't constrain the artist's imagination. Because of Leonardo, not only was a forgettable battle immortalized, but the repertoire of art was expanded to include shouting, struggling men trying to kill each other. His were not the first scenes of modern battle; Paolo Uccello, for instance, had painted battles, but his panels look like storybook illustrations in comparison with Leonardo's furious combat. The packed composition was studied by any aspiring artist who could get to Florence. Ancient battle sarcophagi no longer looked so impressive compared to Leonardo's mêlée, so replete with blood, confusion and turbulence. Rubens' watercolour, showing the centre of the battle, is a copy of copies, since Leonardo's ruined, unfinished mural was lost when the present undistinguished battle scenes were made in the 1560s.

Fig. 34
Peter Paul Rubens (1577–1640)
Copy after Leonardo's
Battle of Anghiari
*c.*1603. Black chalk, pen, ink,
heightened with white lead,
reworked in watercolour,
45.2 × 63.7 cm.
Musée du Louvre, Paris

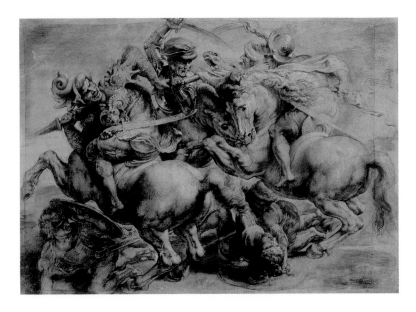

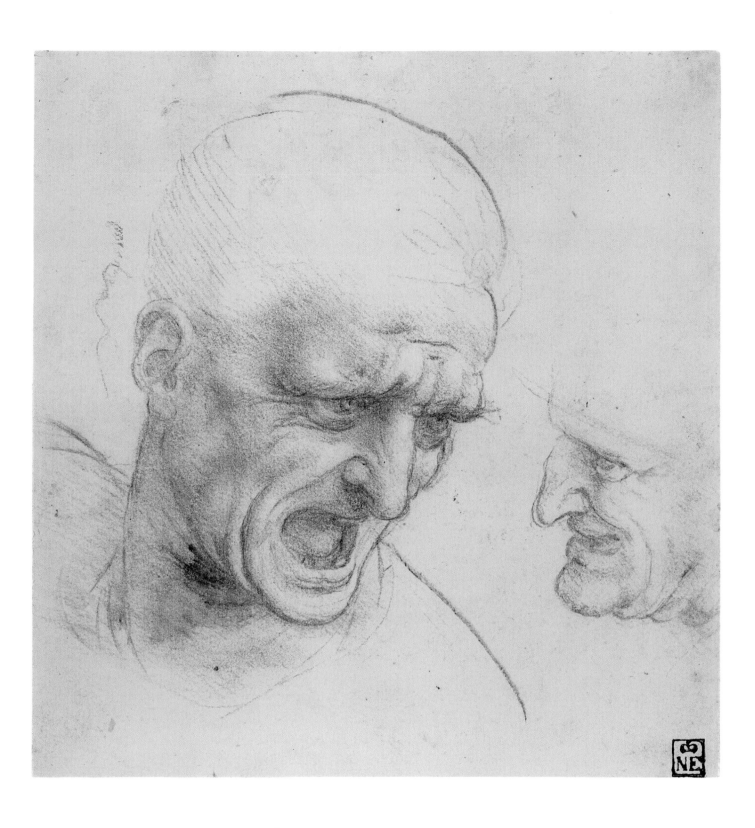

The Madonna and Child, with Saint Anne and Lamb

*c.*1510–13. Oil on poplar, 168 × 130 cm. Musée du Louvre, Paris

Fig. 35
Study of the Drapery of a
Figure Seated to the Right
*c.*1501 or 1510/11(?). Black chalk,
washed with Indian ink and
heightened with white,
23.1 × 24.6 cm. Cabinet des
Dessins, Musée du Louvre, Paris

Presumably a rethinking of the London cartoon (Plate 31), the Louvre picture places the Virgin at the centre, but bent over and reaching for the Christ Child, who is playing with a lamb – symbolizing, as a contemporary source reminds us, his Passion to come. Saint Anne smiles, Vasari explains, because she sees her descendants becoming heavenly beings; Freud detected there a memory of Leonardo's lost birth mother. Whether there was ever a commissioner for the long-standing project is unknown; it is likely that Leonardo began the cartoon in Florence on commission from the Servites of Santissima Annunziata, and later interested his French overlords in Milan in the project. The rocky landscape, so beloved of the artist, seems to have signified the vastness of the past to him, when sea and mountain heaved in barely imaginable ways, leaving fossils on mountaintops.

The composition solved the problem of how to portray the lower bodies of Saint Anne and Mary – that awkward succession of legs and knees and feet – although at the cost of exposing somewhat more the basic incommodiousness of an adult sitting on another adult's lap. The compositional type, showing three generations of the the Holy Family, went back to medieval times; even Leonardo had some trouble translating such a topic into naturalistic terms. Theologically speaking, his Christ becomes a remarkably ordinary child, somewhat displaced by the loving mother. Raphael's *Alba Madonna* shows a similar, though more restrained, stretch of the Madonna towards a Child between her knees; it is possible that Raphael saw an early version of this painting when they were both in Florence, soon after the making of the London cartoon.

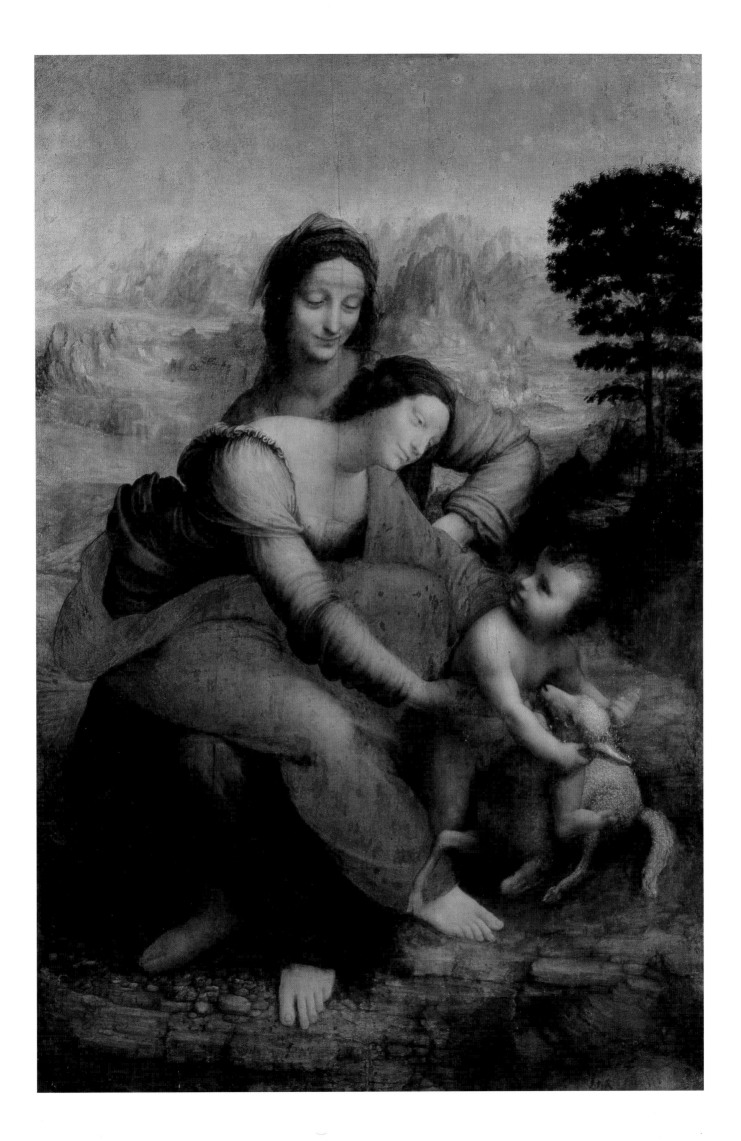

The Virgin of the Rocks

*c.*1495–9 and 1506–8. Oil on poplar, 189.5 × 120 cm.
National Gallery, London

Anyone who would deny that the London version of the *Virgin of the Rocks* should be attributed, at least in part, to Leonardo has to explain the beauty of the painting of the angel. Her iris edges shine; the eyelids puff slightly; the curls catch the light differently depending on how much shadow they are in and whether they are seen against a bright or a dark surface. The top layers of the drapery float like gossamer, their gold threads glistening. Her throat catches the light, while the bottom of the chin and the creases in the neck are less darkly shadowed than the deeper parts. The shadow from the nose ever so subtly makes us aware of the slight trough in the skin above the lip. The transition between cheek and neck is completely believable and yet utterly indefinite.

No youth on the sidelines, the London angel rivals the Virgin in beauty. More appropriately, we might say that the Virgin is quasi-angelic in her beauty, and the inclusion of the angel at her side is meant as a compliment.

In the Paris version (Plate 15), the red and green angel (similar colours to the angel of the Uffizi *Annunciation*, Plate 5) pointed the viewer to John the Baptist in a kind of displacement (since John the Baptist normally points at Christ); in the London version both of the angel's arms support the Child and her gaze is vaguely towards the centre. She is lost in a meditative haze. No figure had ever looked so full of ineffable thought.

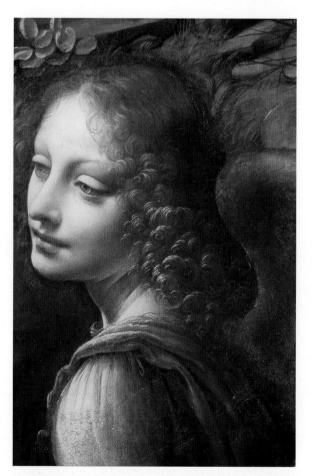

Fig. 36
The Virgin of the Rocks
(Detail)

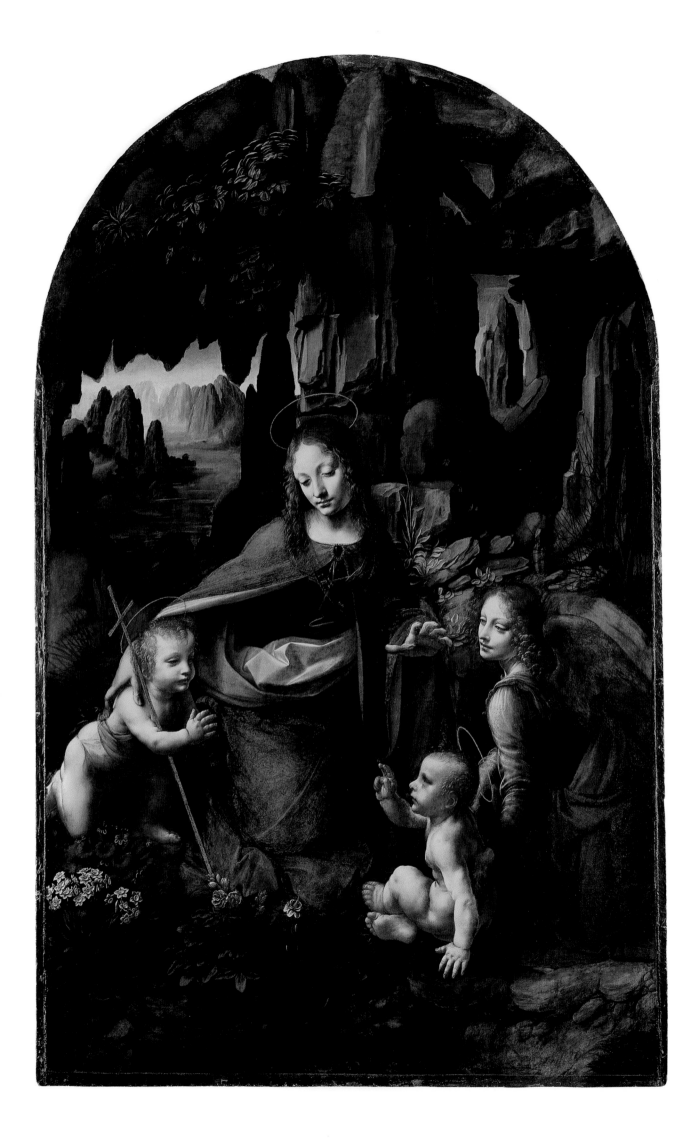

The Virgin of the Rocks (Detail)

National Gallery, London

Mystery is a quality that has long been associated with Leonardo's art, and it pertains not least to his sense of landscape. Such geological formations and lagoons as these must always have been understood as largely imaginary. Their appeal lies in the juxtaposition of liquid and solid, mobile and stationary, each accentuating the other as Leonardo also used light and shade dichotomies. This impenetrable landscape must have startled viewers unused to such a setting for the Virgin and Child. Mantegna, another artist much intrigued by the potential of landscape painting, made a small devotional painting that showed Virgin and Child against a mountainside, but probably later than Leonardo made his first large-scale version of this altarpiece.

Instead of showing the Virgin either as Queen in a throne room, or as humble handmaiden on the ground, Leonardo placed her in an environment that his notebooks would suggest he found fear-inducing. Instead of familiarity, his landscape established religious mystery; and instead of placement in a walled garden, the Virgin is situated in a forbidding and inaccessible terrain. Although deeply tied into Leonardo's private imagination, the landscape was also appropriate for a Confraternity of the Immaculate Inception intent upon augmenting the Virgin's theological status.

A Branch of Blackberry

*c.*1505–10. Red chalk with touches of white heightening on pale red prepared paper, 15.5 × 16.2 cm. Royal Collection, Windsor

This drawing of a marsh-loving plant may be associated with the project for painting *Leda*. It is, characteristically for Leonardo, both a nature study and a beautiful rendering, with some lines barely indicated and other sections richly worked in tone, including careful background hatching. Red chalk offered Leonardo a medium in which he could be both linear and tonal, like an etcher who has discovered the supplement of aquatint. The heavy bough, bent under its own weight, is both more like nature than contemporary botanical illustration and inestimably more compelling as an image. One of the measures of Leonardo's greatness is that he could make a branch of a scrub bush into a harmonious equilibrium of shape and colour, at once thick and convincingly messy, yet organized into a graceful arc, full of information about the plant and nevertheless as full of form and movement, contrast and complementarity as any figural subject. His drawing is neither purely preparatory nor a finished work of art in its own right, but rather, an accurate yet artistic study of nature.

The study of violas, roses and other flowers (Fig. 37) shows the painstaking study he devoted to whatever caught his eye, as though by analysing it through drawing, he could understand it. For all that he was a master of creating the illusion of shadowy recesses, he could also work purely in line.

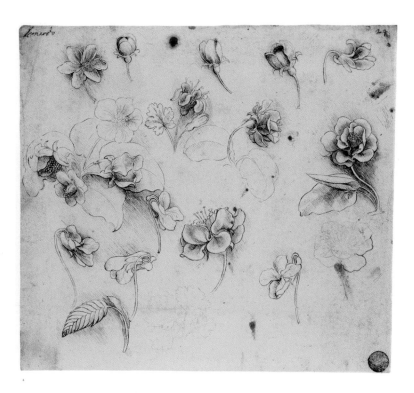

Fig. 37
Studies of Flowers
*c.*1483. Pen and ink over
metalpoint, 18.3 × 20.3 cm.
Gallerie dell'Accademia, Venice

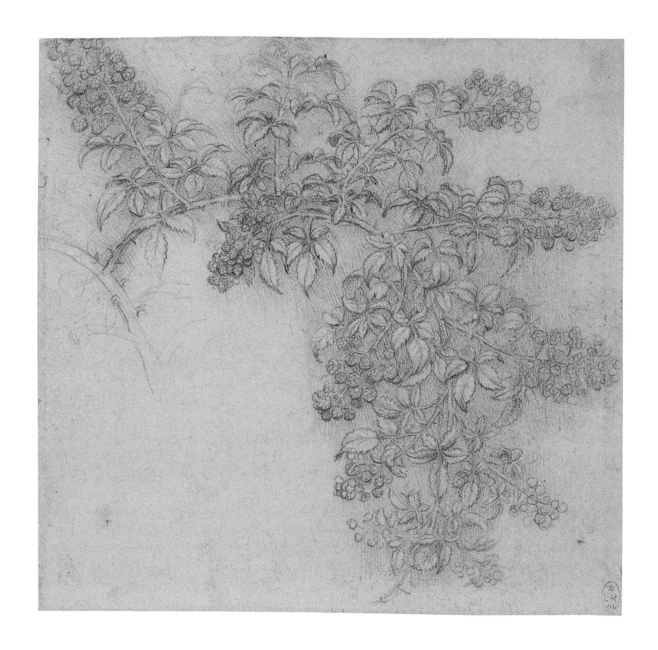

Study of Mountains

*c.*1510. Red chalk on pale red prepared paper, 15.9 × 24 cm. Royal Collection, Windsor

Leonardo was ahead of his time, not least in his admiration for rugged mountain ranges. He repeatedly painted hard crags dissolved by mist in the blue distance. He wondered at fossils found high up in the mountains, and noted that the rocks told of a time in the past before writing existed. In telling the history of the world, visual evidence could claim primacy.

The Alps are visible not far north of Milan, but Leonardo was painting mountains, fantasy mountains, even before he moved away from Florence. Once he gained access to the sight of great mountain ranges, though, he made careful studies of the way these monumental, complex forms took the light. His attempts to reproduce these effects on tinted paper offered the occasion for new ways of drawing: done on a small scale, these families of gigantic, inflected forms float on the paper, shrunk to miniature size, retaining the sense of connection from peak to peak, and yet avoiding any unified finite contour. If Leonardo's stylistic quest consisted of an attempt to find alternatives to the silhouette, such delicate chalk mottlings as this one epitomize his efforts. He was trying to draw the effects of light refracted by water in the air, over long distance.

The notes to himself are reminders about details of the colour effects: where blue, ochre, violet, yellow and white are seen in the distance, and observations about the visibility of scattered foliage.

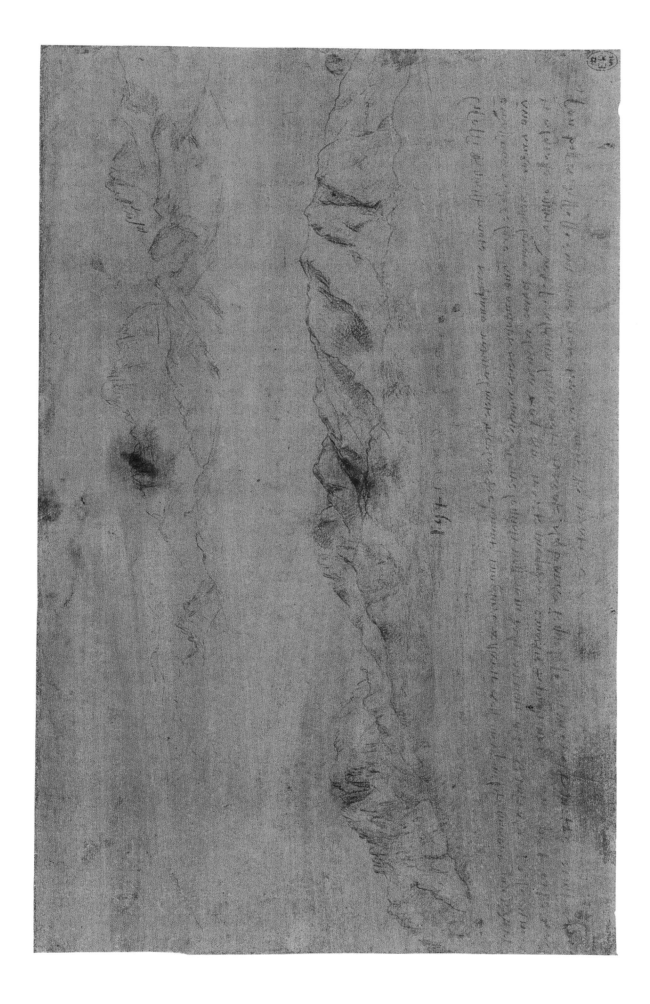

*c.*1510–13. Pen and ink and wash over red and traces of black chalk,
30.4 × 22 cm. Royal Collection, Windsor

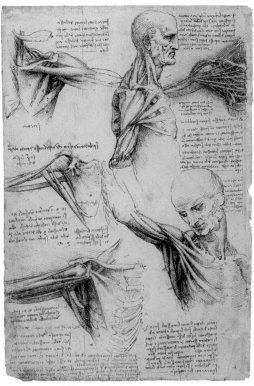

Fig. 38
Anatomical Analysis
of the Movements of the
Shoulder and Neck
*c.*1509/10. Pen, three shades of
brown ink and wash over black
chalk, 29.2 × 19.8 cm.
Royal Collection, Windsor

It is thought that Leonardo may have made notes on this sheet over a period of years. Whether he ever dissected a pregnant woman is not known, but it is certain that he dissected a pregnant cow and it seems that he thought that the two were more alike than they really are. Some of what appears here, such as the Velcro-like cotyledons in the upper right, have been transposed from close study of a cow's uterine lining. The remarkably plump foetus is shown in breech position; the simple sketch of the sphere on an inclined plain to its right has been explained as a diagram about how the foetus may rotate in the womb before birth. Experts assure us that while the sheet displays misinformation, it proves that Leonardo understood anatomy better than anyone else in his time, including Marcantonio della Torre, professor of anatomy at Padua and later Pavia, who died of the plague at the age of thirty, and to whom Leonardo may refer in a note on this page. Leonardo, along with others of his time, did not believe that a foetus had an independent heartbeat, as his notes here indicate.

The use of red chalk in the figure of the foetus greatly enhances its aesthetic effect. This sheet should be understood as an attempt to understand through visualizing, more than as a simple record of dissection. Sometimes Leonardo used injections of wax to help clarify the pockets and layers of structure he wanted to study, in which procedures some of his bronze-casting skills were not irrelevant. A small diagram of binocular vision can be seen, lower right.

In his drawing of the muscles and bones of the shoulder (Fig. 38), he strove to maintain clarity as he described a very complex system of moving parts. The notes are written to himself as reminders of what the drawings should accomplish; he had hoped to publish a treatise, which presumably would have had printed illustrations.

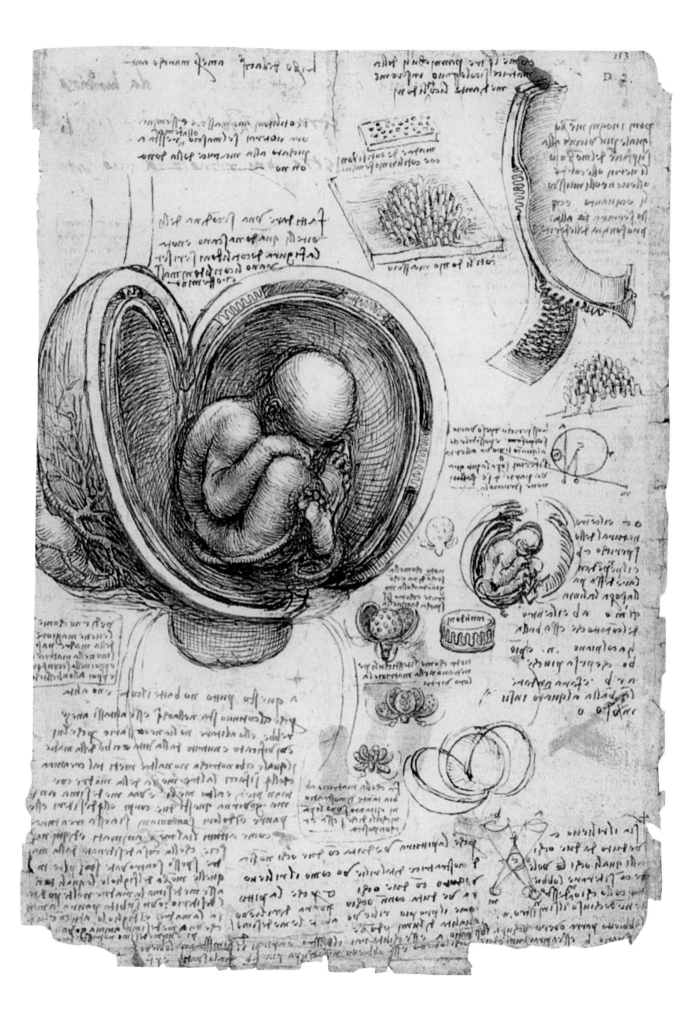

Sheet of Studies of Horses, a Cat and Fight with a Dragon

*c.*1508. Pen and ink over black chalk, 29.8 × 21.2 cm. Royal Collection, Windsor

We don't know that Leonardo ever made a painting of Saint George, but he certainly thought about the subject, as documented by this sheet. He seems to have started with a crouching cat, then rapidly arrived at twisting, writhing horses, includes some horses suitable for an equestrian monument, then ended up with a battle between Saint George and the dragon, the wildest, most intertwined composition of all. Modelling within the contours and some basic hatching outside are all that is needed to create a believable space in which the foreshortened forms twist and turn.

Observations flow imperceptibly into imagination again in a similar sheet of sketches (Fig. 11), which range from a study of a sleeping cat to a hunting feline. Some of the tussling or growling creatures may be puppies rather than cats. Almost as in cartoons, the domestic cat transforms before our eyes into a lion and from thence into a dragon. Perhaps Leonardo sat watching a cat wash itself, or crouched in apprehension, and then extrapolated to the animal with its hair all on end in fright – or perhaps it was all done from imagination. In either case, this sheet provides a revealing record of how one idea led to another.

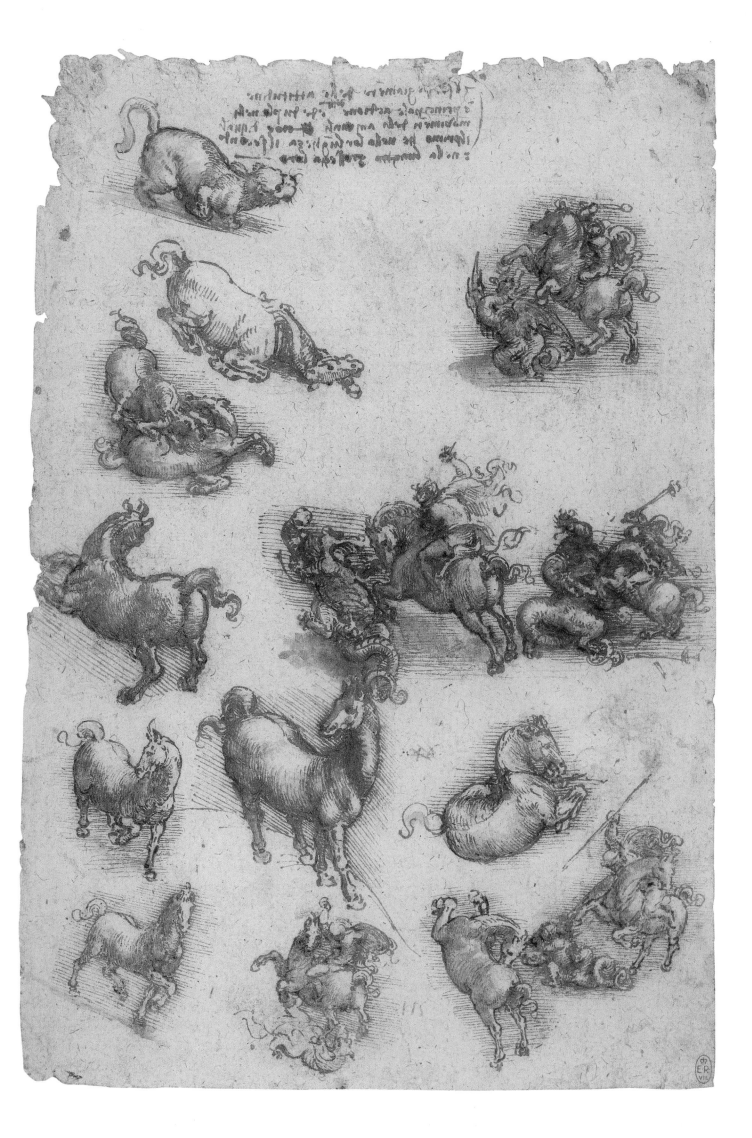

46 Deluge (Tempest over Horsemen and Trees with Enormous Waves)

*c.*1517–18. Black chalk, pen and ink and wash with touches of white heightening on grey prepared paper, 27 × 40.8 cm. Royal Collection, Windsor

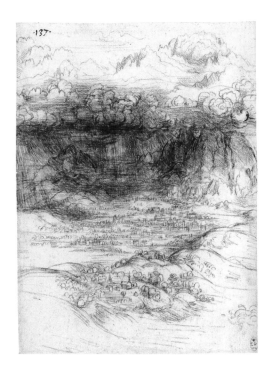

Fig. 39
Storm in an Alpine Valley
*c.*1508–10. Red chalk on paper,
19.8 × 15 cm.
Royal Collection, Windsor

Leonardo's ability to think in visual groups was invaluable in imagining clusters of enraged horses storming against each other. In one of his drawings we can see horses baring their teeth alongside a lion and a man doing the same; Leonardo was always alert to visual analogies, battle and storm being one such pairing.

A storm moving over a landscape was not considered a congenial subject for an artist before Leonardo, who found its combination of force and visual indistinctness fascinating. To draw darkness and obscurity was a challenge; even harder was conveying the destructive power of wind. Battles similarly presented the chance to draw overwhelming, rapid devastation. The *Deluge* drawings, together with the deluge prose poems he wrote for himself, show how well this arch-empiricist managed to reconcile knowledge with an imagination that was fundamentally unlike the imaginations of his contemporaries.

The same imaginings about water and rock that prompted the background of, for instance, *The Virgin of the Rocks* (Plates 15 and 40), were still with him when as an old man he drew these *Deluge* subjects repeatedly, showing storm and mountain in cataclysmic opposition, rather than peacefully coexisting as they had in the earlier composition.

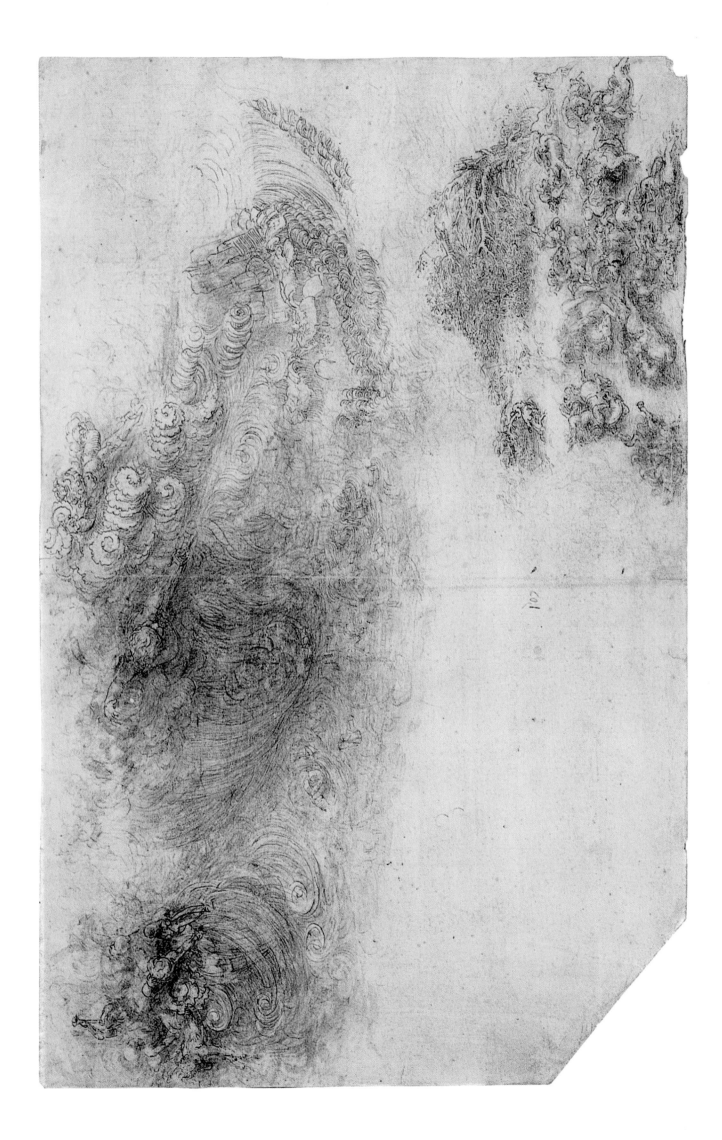

c.1515. Black chalk, 15.8 × 21 cm. Royal Collection, Windsor

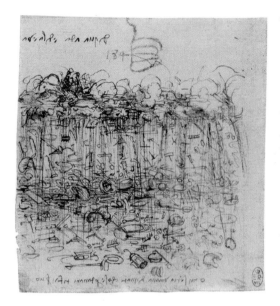

Fig. 40
Implements Rained
Down on the Earth from
the Clouds
c.1498. Pen and ink,
11.7 × 11.1 cm.
Royal Collection, Windsor

The eloquent Walter Pater described Leonardo as a man haunted by two kinds of images: 'the smiling of women and the motion of great waters.'

If Leonardo's obsession in later life with a deluge had any relationship to the Biblical deluge, it was a tenuous one, balanced by the occasional mythological reference (if he thought much about the biblical deluge, it was to wonder how the waters would have been able to disperse). Despite what might look from our perspective like some similarity, it seems that J.M.W. Turner's late seastorms were done without any access to the *Deluge* drawings.

While in declining health, whether while housed in the Vatican or later in France, Leonardo wrote pages and pages, and also drew, sometimes in pen but often in black chalk, scenes of the end of the world through catastrophic flood. Sometimes he showed uprooted trees or writhing figures and horses, tiny and ineffectual by comparison with the great curling onslaught of waves, but often he showed only abstract, immensely powerful, destructive motion. The idea that water could destroy rock formations long held for him an understandable fascination.

The deluge, he wrote, would be seen through air darkened with the rain, and with the rain blown sideways by the wind, somewhat as one sees when great winds whip up dust. The obscurity would be complicated by bursts of lightning and by the rending and recombining of clouds. Even while imagining utter catastrophe, Leonardo was as much scientist as dramatist.

Leonardo drew a storm in which torrents of rain fall down on a variety of ruined objects (Fig. 40). The heavens' destruction of worldly goods is shown on a tiny scale, in the manner of a fable. Whatever there is, Leonardo noted, the painter has it first in his mind and then in his hands.

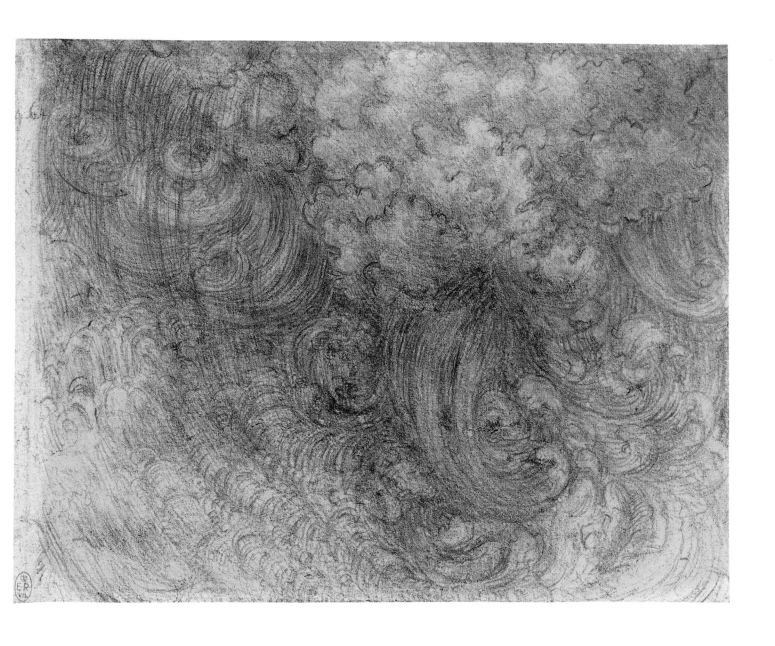

Saint John the Baptist

c.1515. Oil on walnut, 69 × 57 cm. Musée du Louvre, Paris

The saint's glowing skin and hair emerge from the darkness, the head cocked in a way reminiscent of John the Evangelist in Leonardo's *Last Supper* (Plate 26), the finger echoing that of Saint Thomas, and the gesture to breast that of Saint Philip. John, who had pointed to Christ on the day of the Baptism, here points to heaven and smiles. The figure has been endowed with some of the feeling of an angel; the gestures combine the angel's salute to heaven, as typical of an Annunciation, with Mary's characteristically bashful hand to breast. The gesture of pointing to the breast was an increasingly familiar one at this time, taken by many saints in pictures to express their sincerity and their sheer emotion at being present at some holy event. Leonardo's figure is also holding a slender cross, the top of which is visible between thumb and forefinger of the raised hand. Leonardo has here reinvented the icon in the new formal language of Renaissance art.

Although the date is subject to debate, this is generally agreed to be the latest painting we have by Leonardo – who was reported, more than a decade earlier, to be sometimes more interested in geometry than in painting.

A drawing of the saint (Fig. 41), from a much earlier date, seems to be a study from the life. The hatching to the left of the figure is quietly echoed by the diagonal stokes of blue to prepare the paper for the metalpoint, and the gesture follows the same direction. The youthful figure, slightly reminiscent of Donatello's bronze *David*, insinuates a presence that is gentle yet insistent.

A bronze sculpture (Fig. 42) of a preaching Saint John by Giovanni Francesco Rustici (1474–1554) for the north side of the Baptistery in Florence was made, according to Vasari, with the benefit of Leonardo's supervision. Rustici had likewise been trained in Verrocchio's workshop.

Fig. 41
Study for Saint John
the Baptist
c.1476. Silverpoint on blue
prepared surface, heightened
with white, 17.8 × 12.2 cm.
Royal Collection, Windsor

Fig. 42
Giovanni Francesco Rustici
(1474–1554)
Preaching of Saint John
the Baptist
1506–11. Bronze, 2.65 m.
Battistero di San Giovanni,
Florence

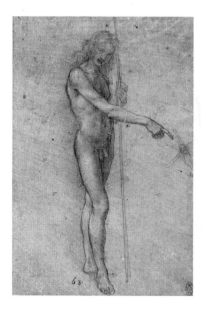
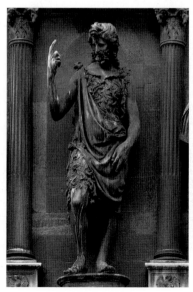

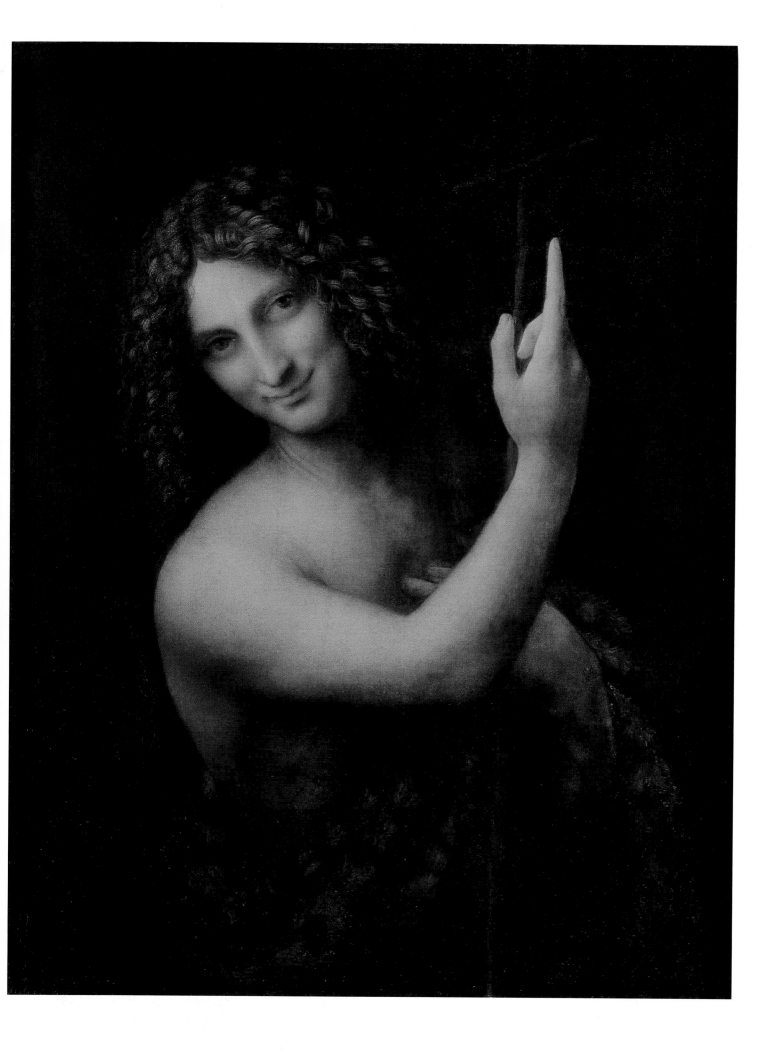

PHAIDON COLOUR LIBRARY
Titles in the series

FRA ANGELICO
Christopher Lloyd
–

BONNARD
Julian Bell
–

BRUEGEL
Keith Roberts
–

CANALETTO
Christopher Baker
–

CARAVAGGIO
Timothy Wilson-Smith
–

CEZANNE
Catherine Dean
–

CHAGALL
Gill Polonsky
–

CHARDIN
Gabriel Naughton
–

CONSTABLE
John Sunderland
–

CUBISM
Philip Cooper
–

DALÍ
Christopher Masters
–

DEGAS
Keith Roberts
–

DÜRER
Martin Bailey
–

DUTCH PAINTING
Christopher Brown
–

ERNST
Ian Turpin
–

GAINSBOROUGH
Nicola Kalinsky

GAUGUIN
Alan Bowness
–

GOYA
Enriqueta Harris
–

HOLBEIN
Helen Langdon
–

IMPRESSIONISM
Mark Powell-Jones
–

ITALIAN RENAISSANCE
PAINTING
Sara Elliott
–

JAPANESE COLOUR
PRINTS
J. Hillier
–

KLEE
Douglas Hall
–

KLIMT
Catherine Dean
–

LEONARDO
Patricia Emison
–

MAGRITTE
Richard Calvocoressi
–

MANET
John Richardson
–

MATISSE
Nicholas Watkins
–

MODIGLIANI
Douglas Hall
–

MONET
John House
–

MUNCH
John Boulton Smith

PICASSO
Roland Penrose
–

PISSARRO
Christopher Lloyd
–

POP ART
Jamie James
–

THE
PRE-RAPHAELITES
Andrea Rose
–

REMBRANDT
Michael Kitson
–

RENOIR
William Gaunt
–

ROSSETTI
David Rodgers
–

SCHIELE
Christopher Short
–

SISLEY
Richard Shone
–

SURREALIST
PAINTING
Simon Wilson
–

TOULOUSE-LAUTREC
Edward Lucie-Smith
–

TURNER
William Gaunt
–

VAN GOGH
Wilhelm Uhde
–

VERMEER
Martin Bailey
–

WHISTLER
Frances Spalding